The Mike DUBISCH Sketchbook Volume two

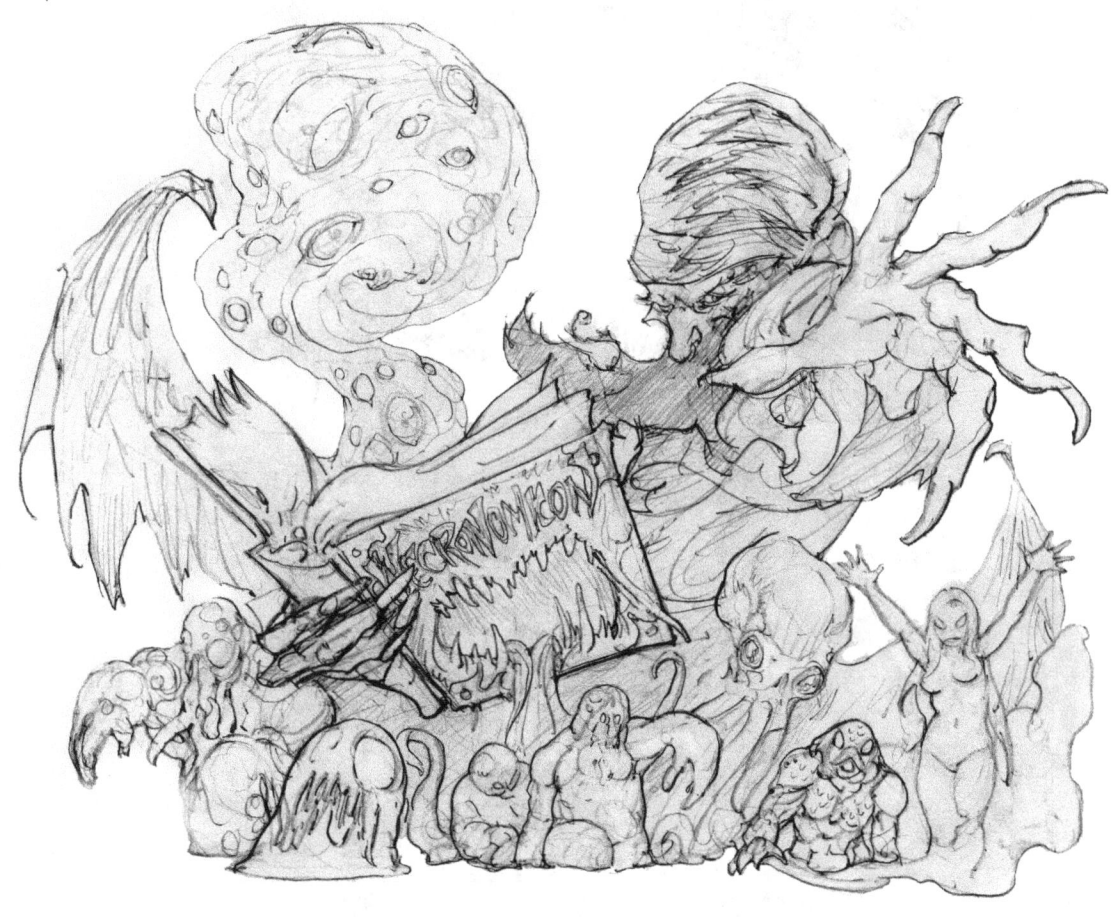

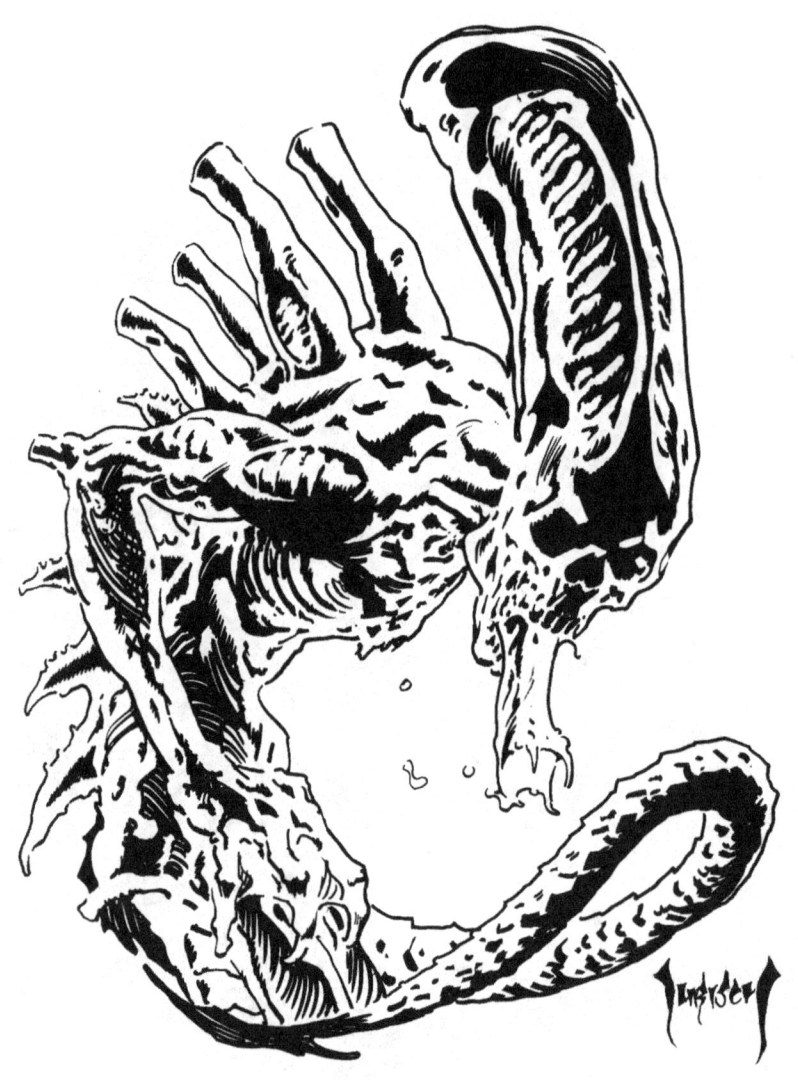

The Mike Dubisch Sketchbook Volume Two
© Mike Dubisch
Published by Mike Dubisch

All characters and worlds depicted are
copyright and trademark their respective creators
and copyright holders.
No portion of this book may be reproduced in any form without
permission from the publisher, unless it is for
the purpose of review.

The Mike Dubisch Sketchbook series is a review of past
and current sketches and drawings by artist/creator
Mike Dubisch.

Published on Earth

THE MIKE DUBISCH
SKETCHBOOK
VOLUME TWO

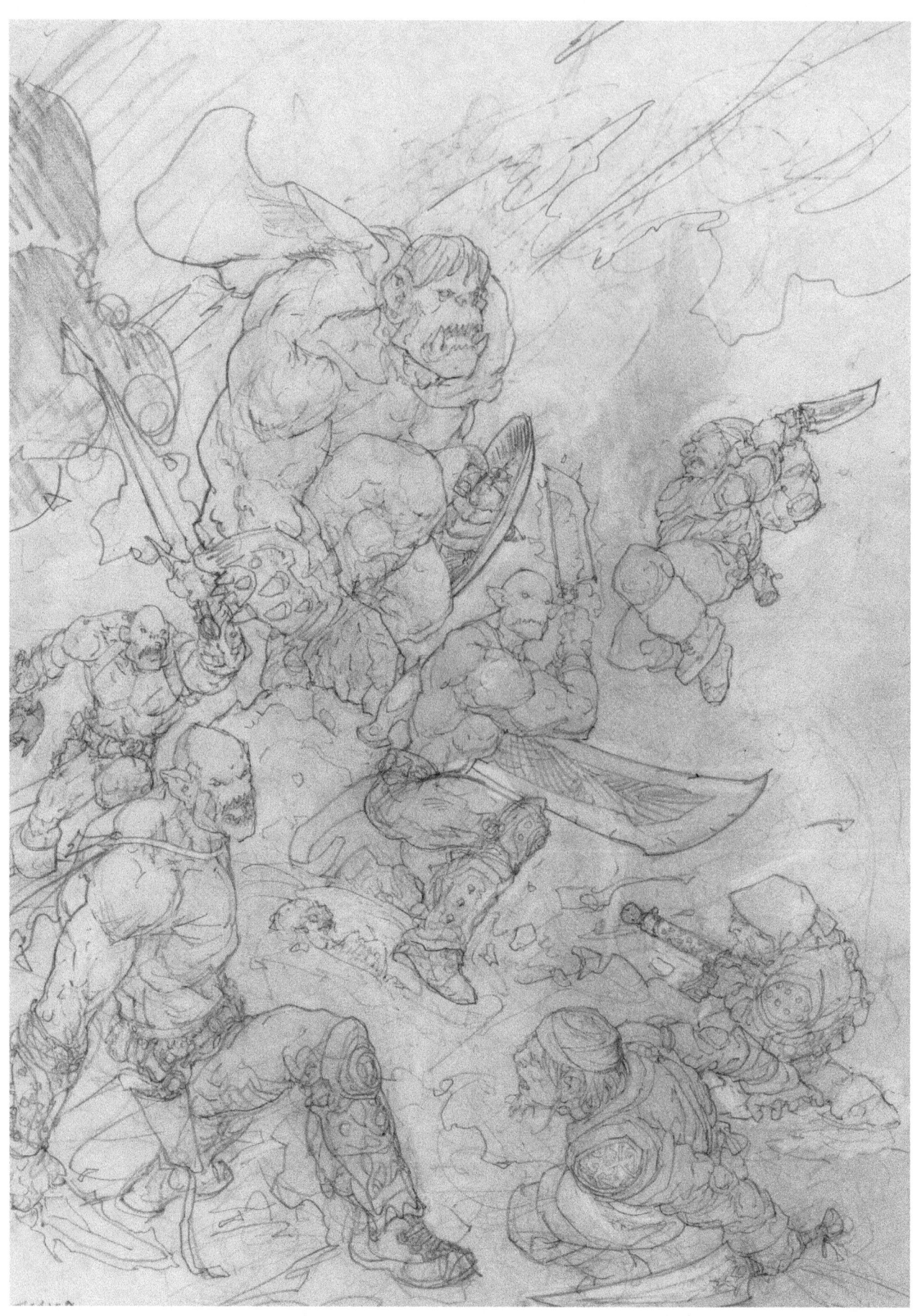

Welcome to the second volume of the Mike Dubisch Sketchbook Series.

These volumes compile the best and most elaborate of my drawings, sketches, and black and white illustrations from the last few years.

In addition to personal work and sketchbook play, this volume contains a drawing of the Xenomorph from the ALIEN film and comic book series, which I have contributed to professionally, as well as an illustration of Dave Steven's The Rocketeer which I did as a try-out for an illustrated collection.

I've included a little film development work, a great deal of sketches for role playing game illustrations, some of the art and preliminary phases of my work for bands around the world, sketches for book and magazine covers, and more unpublished card game art.

In this volume I'm also sharing a selection of life drawings and still life studies.

The book closes with some art for various Shannon Eric Denton graphic novel projects and few pages I created for best selling fantasy author John R Fultz for a proposed graphic novel tie in to his "Seven Princes" series.

I hope you enjoy this new selection of images.

Mike Dubisch, 2015

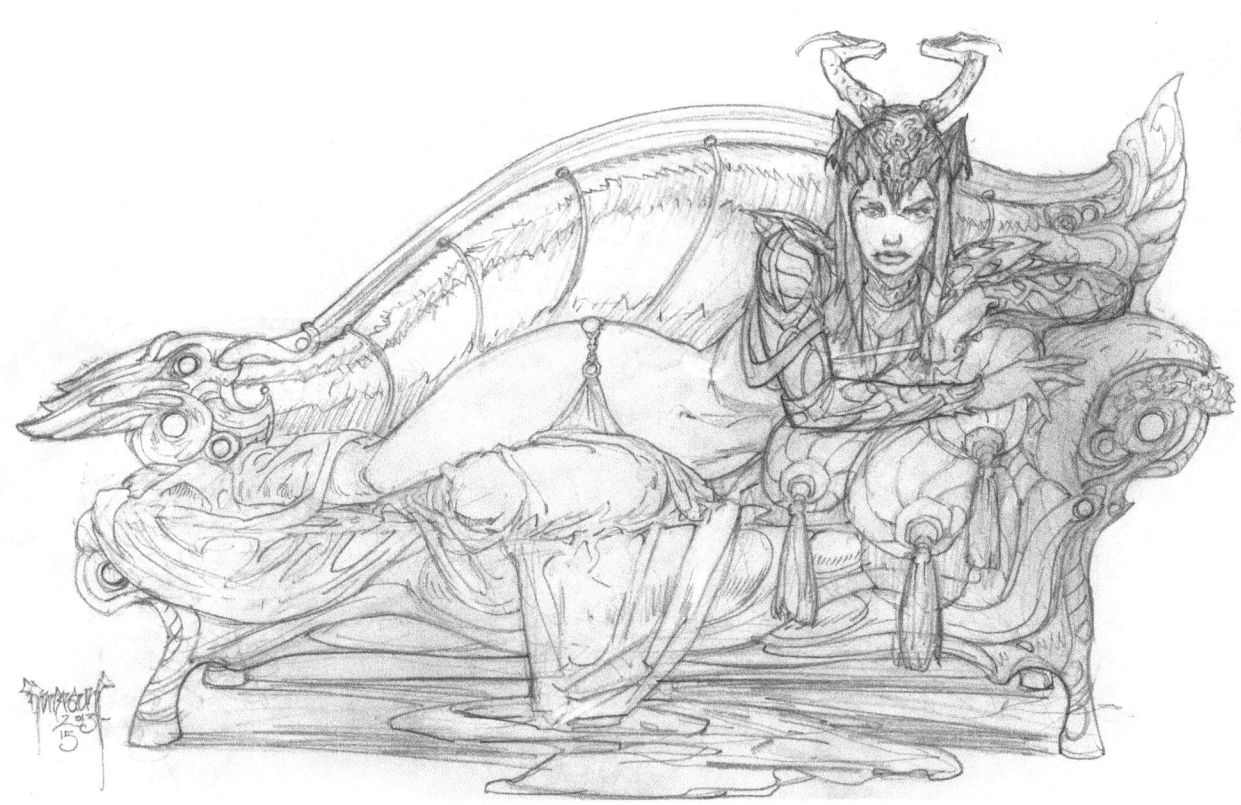

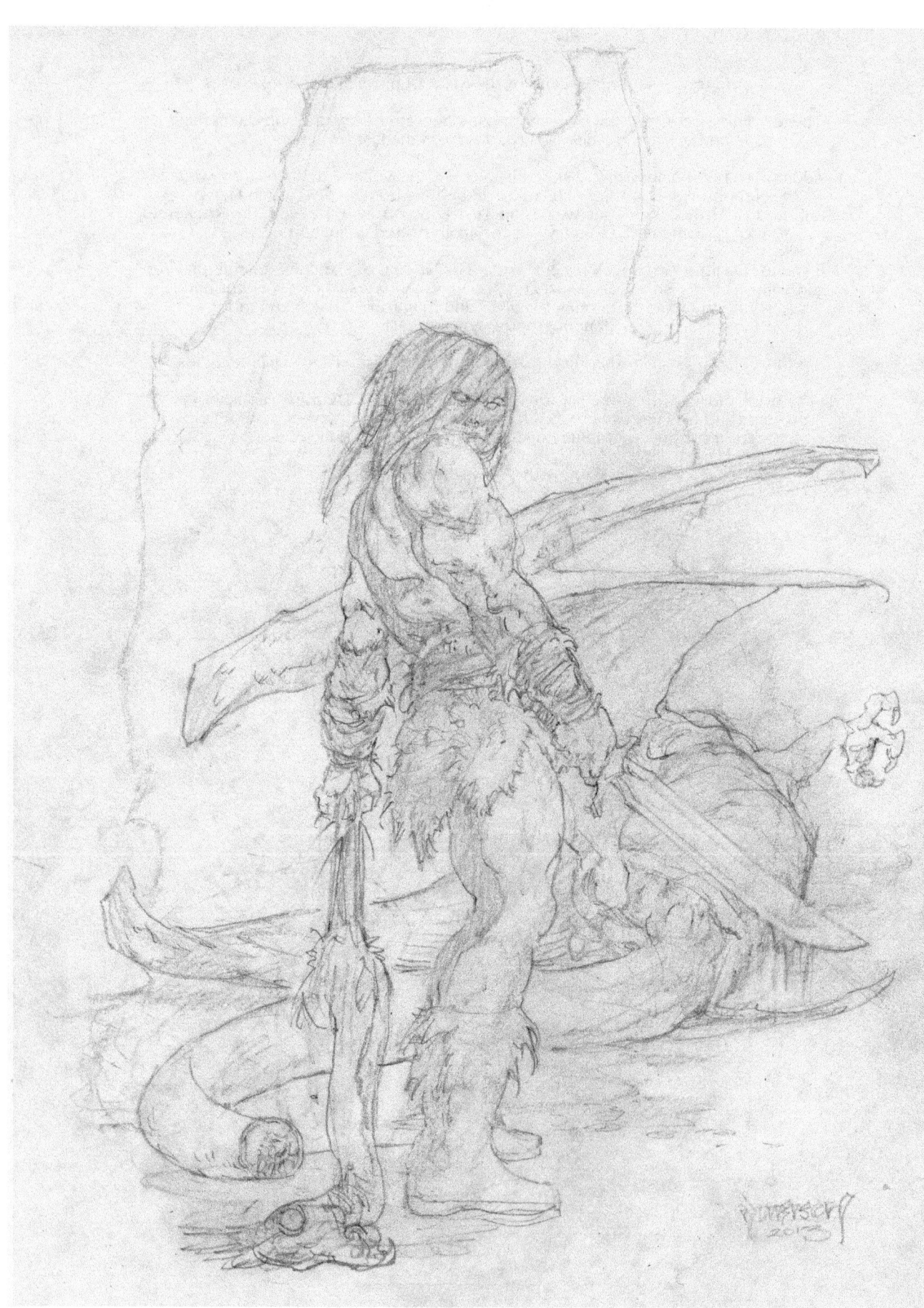

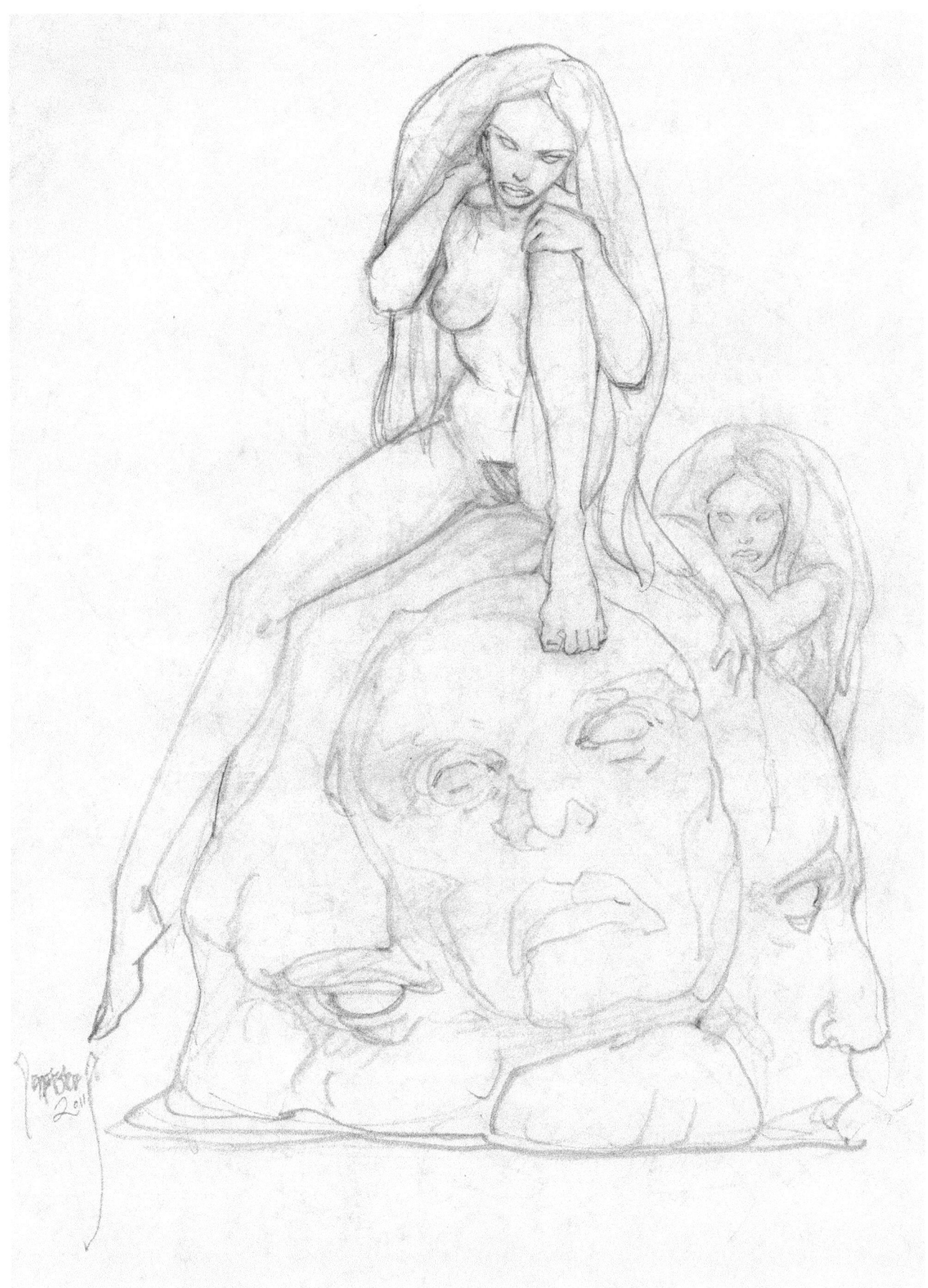

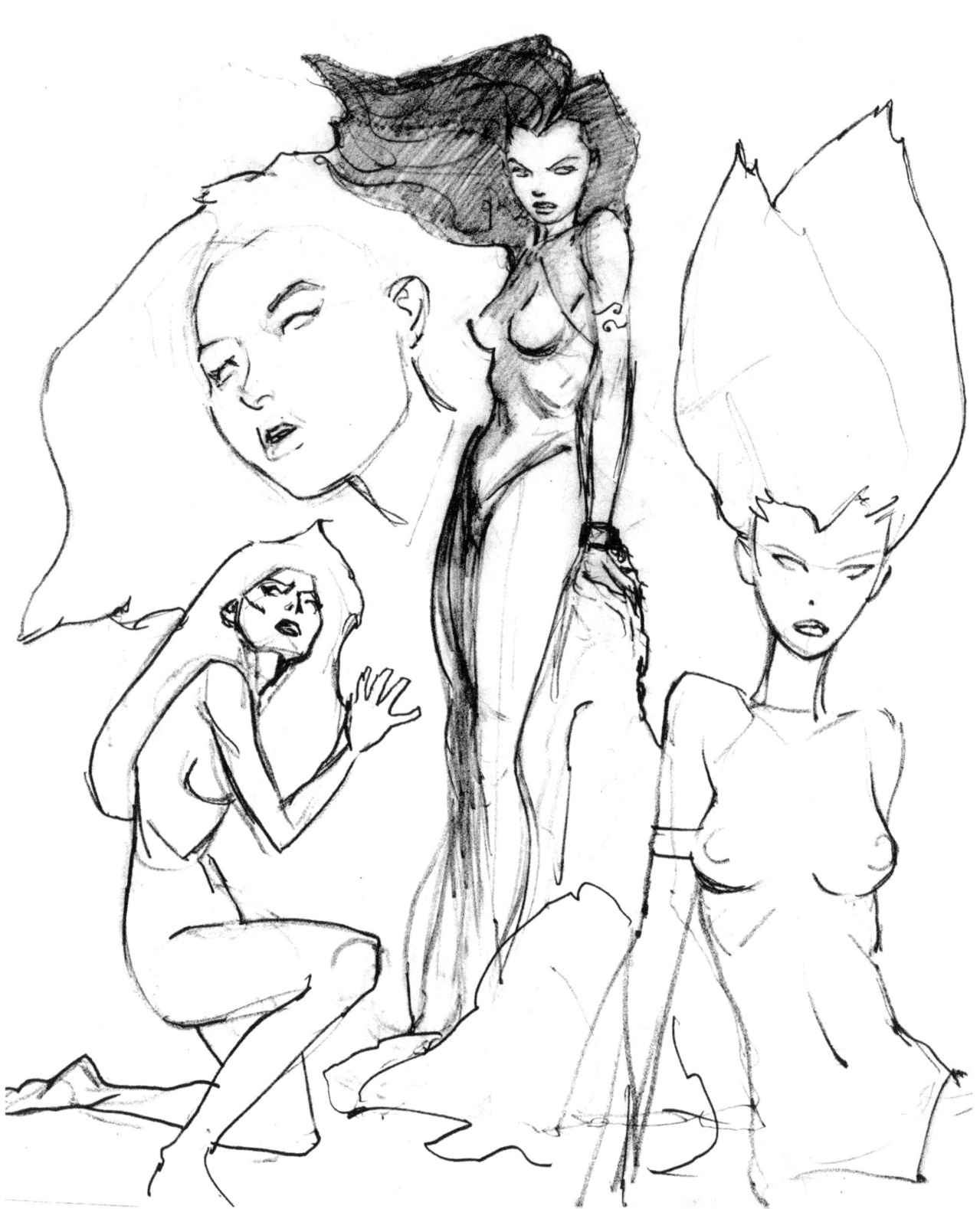

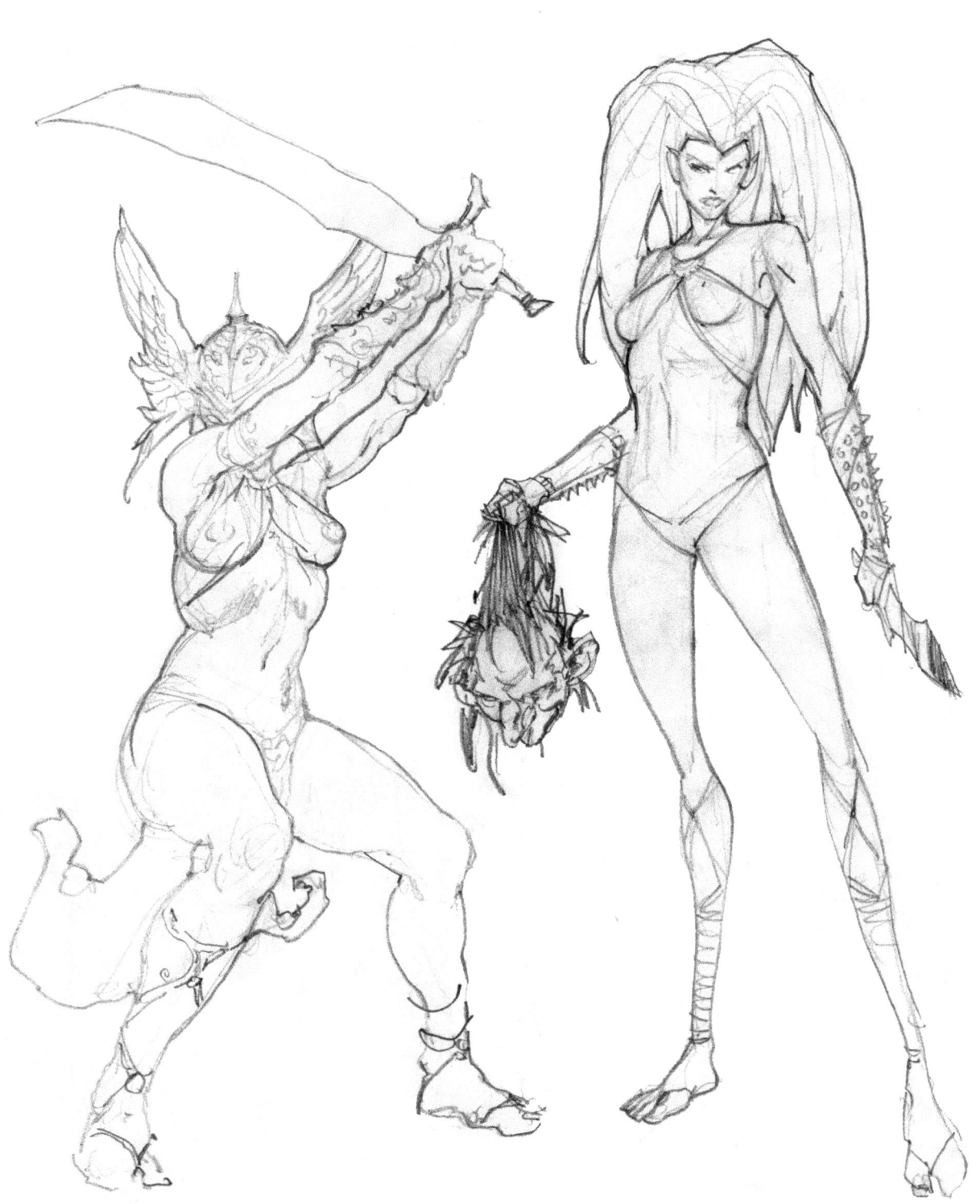

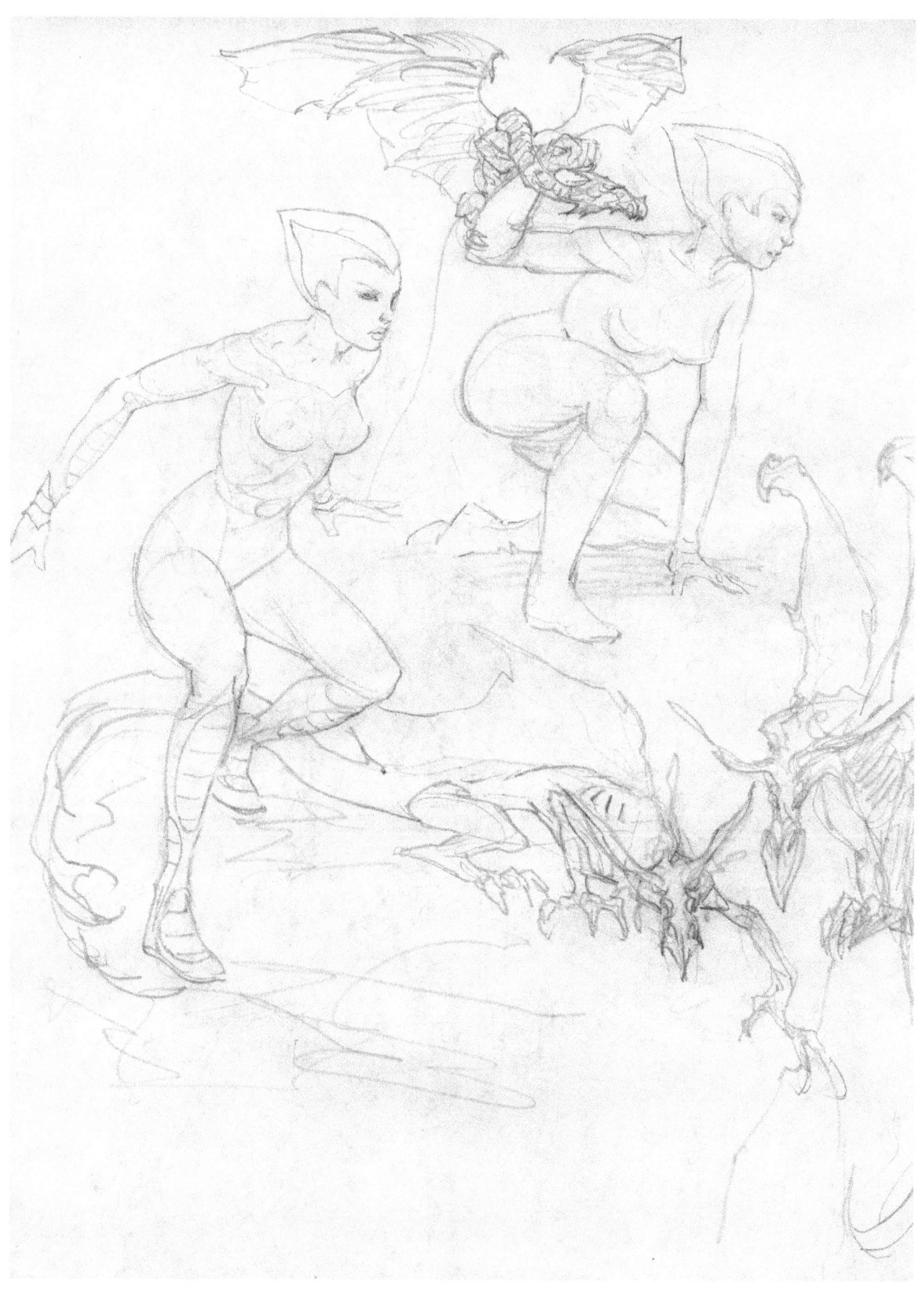

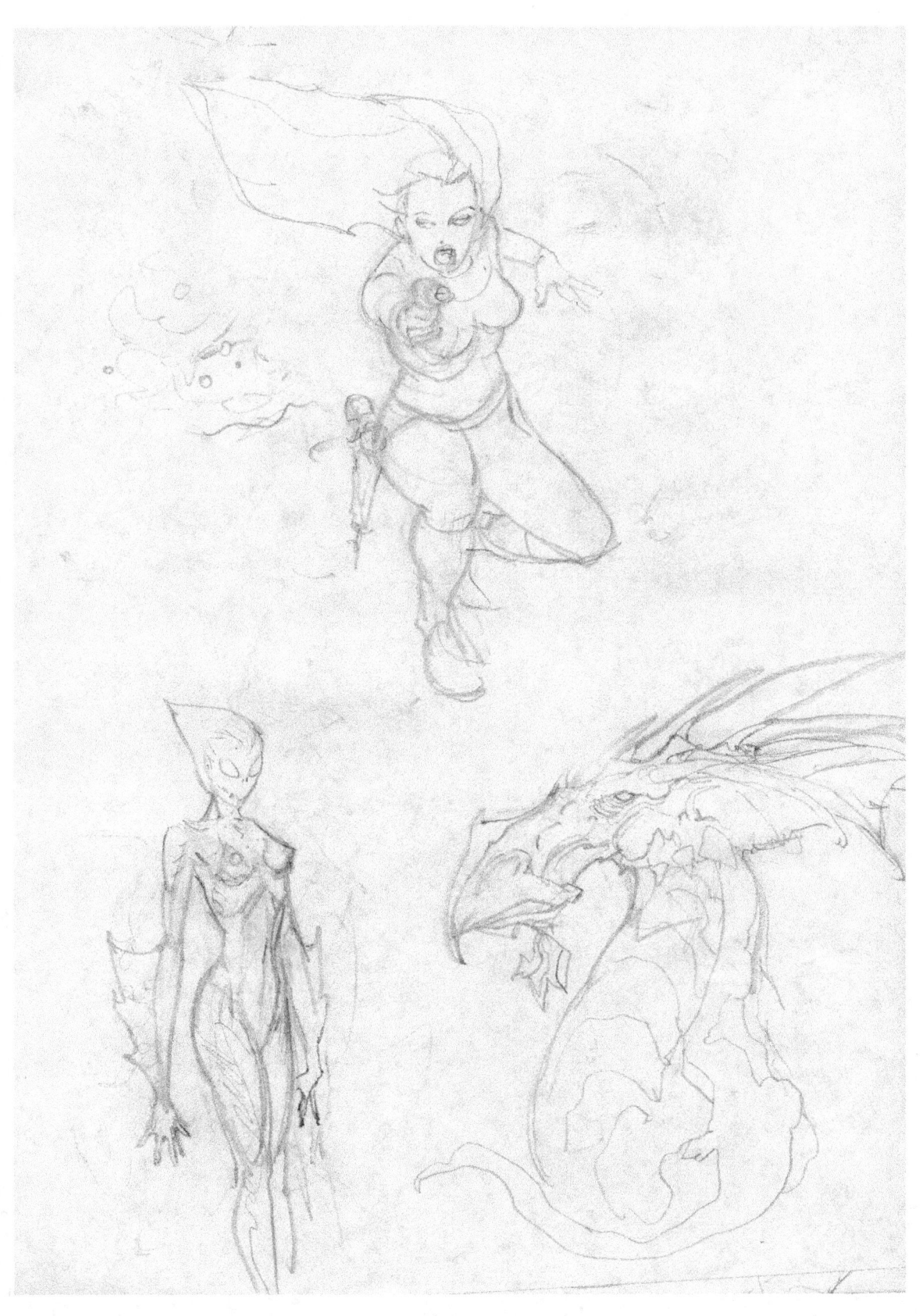

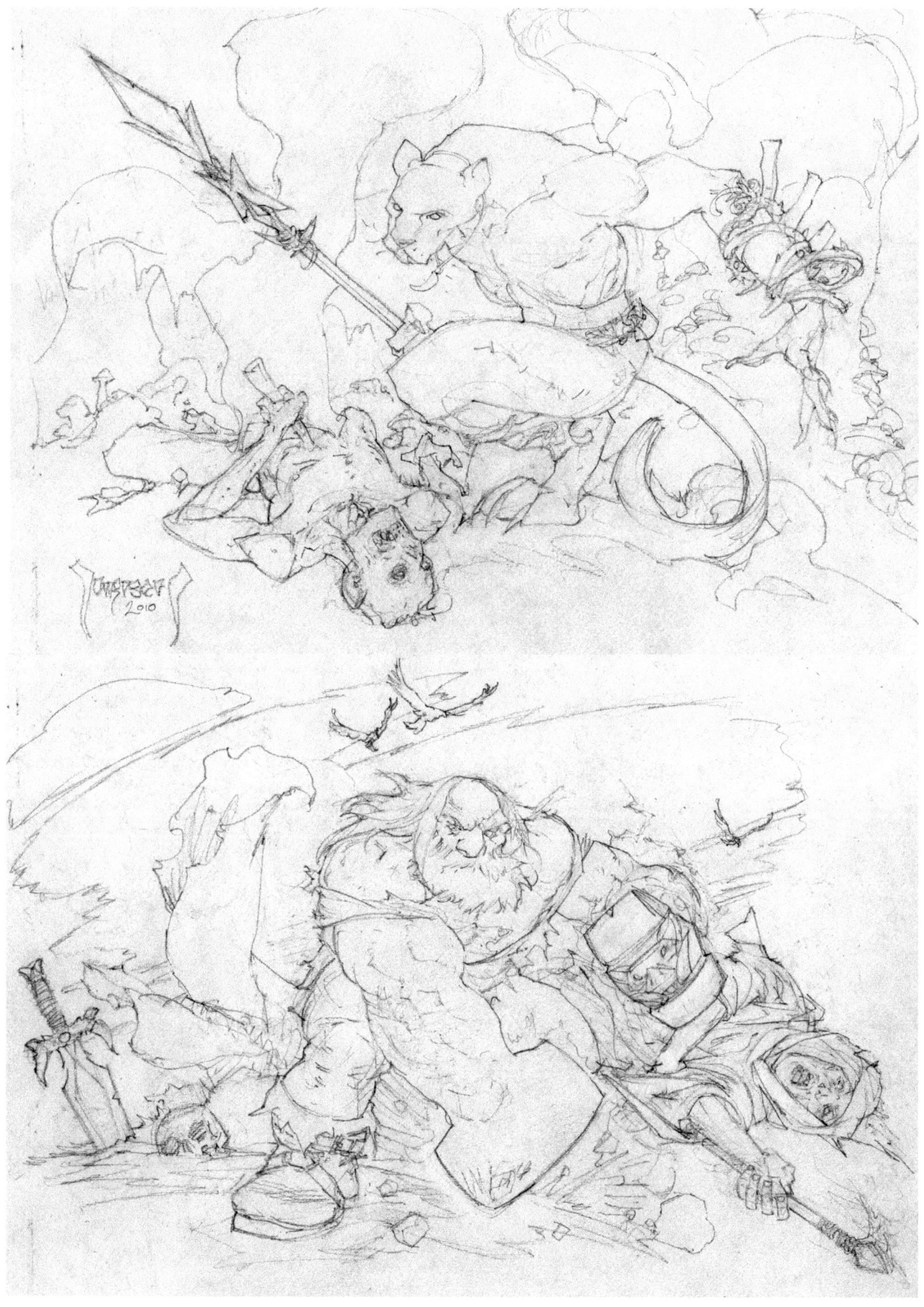

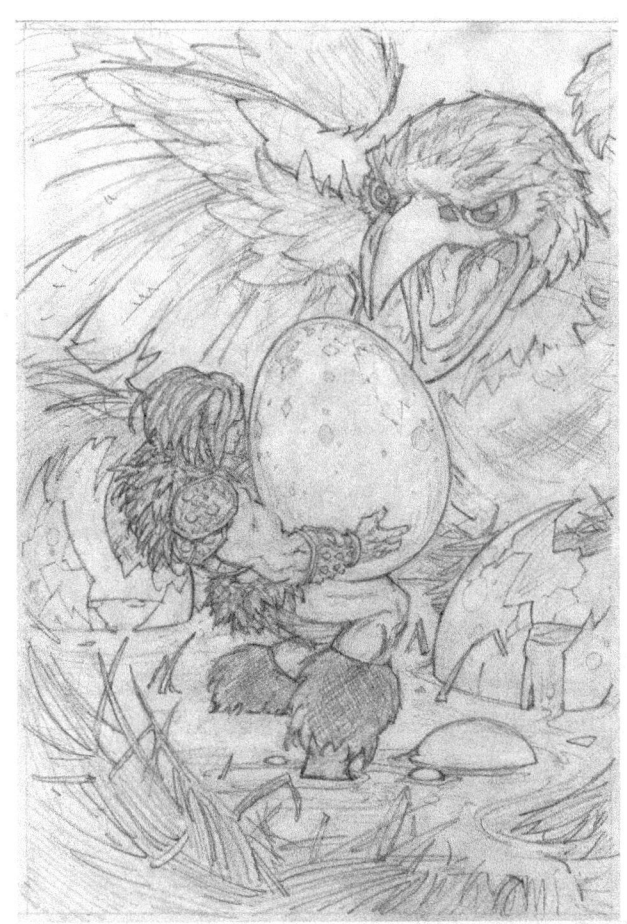
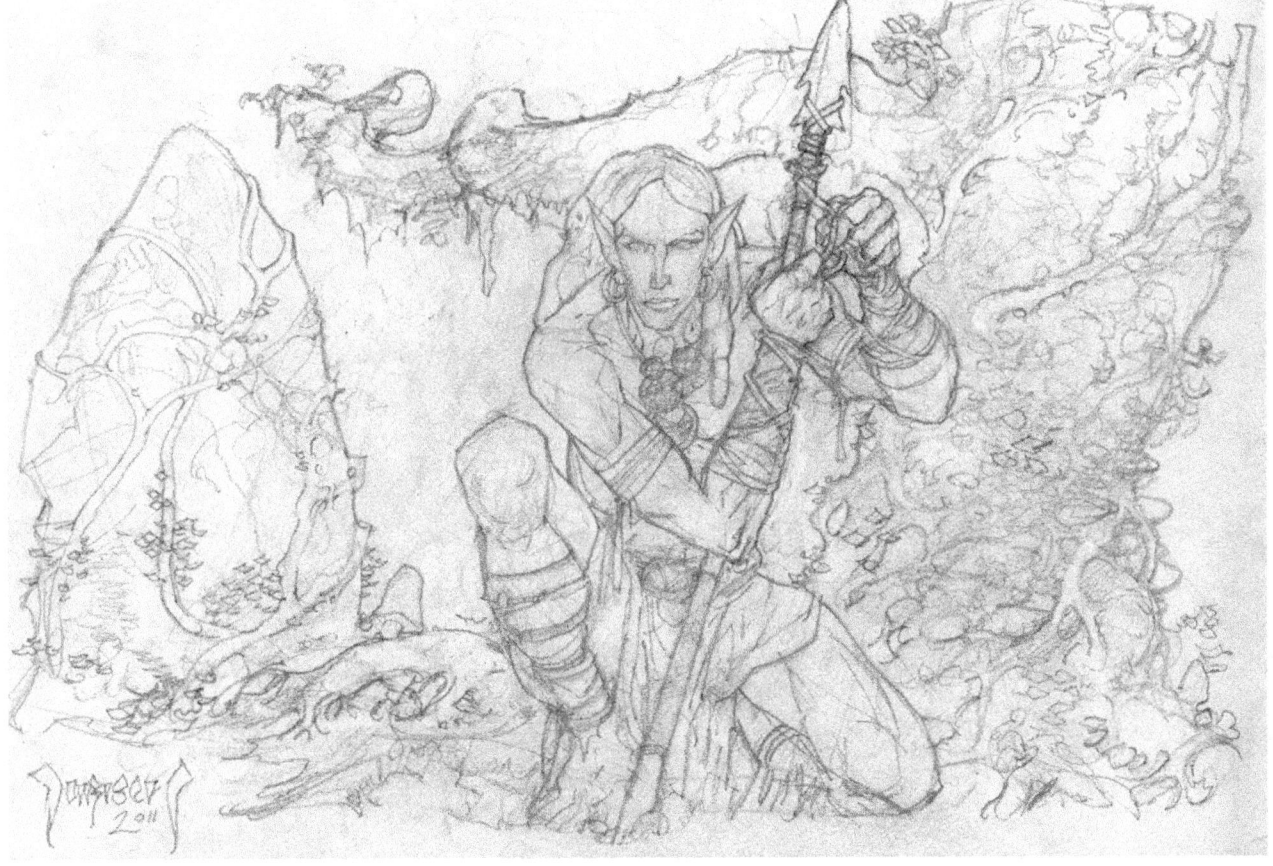

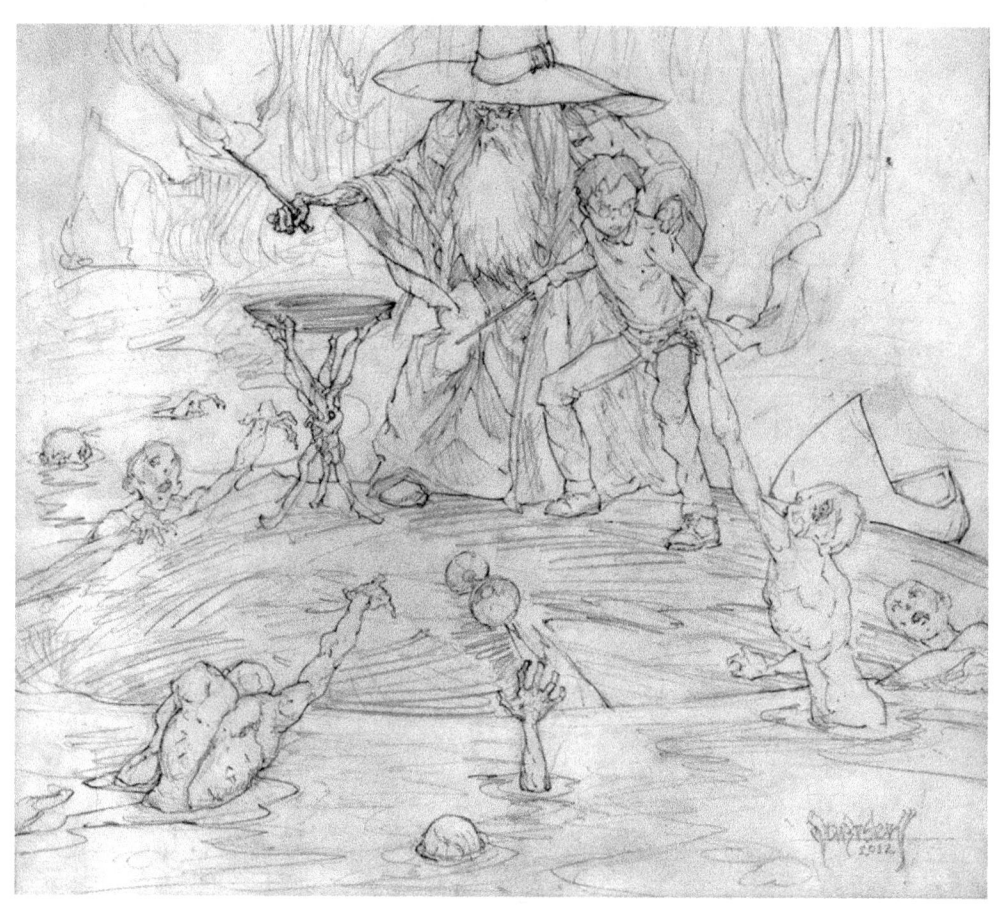
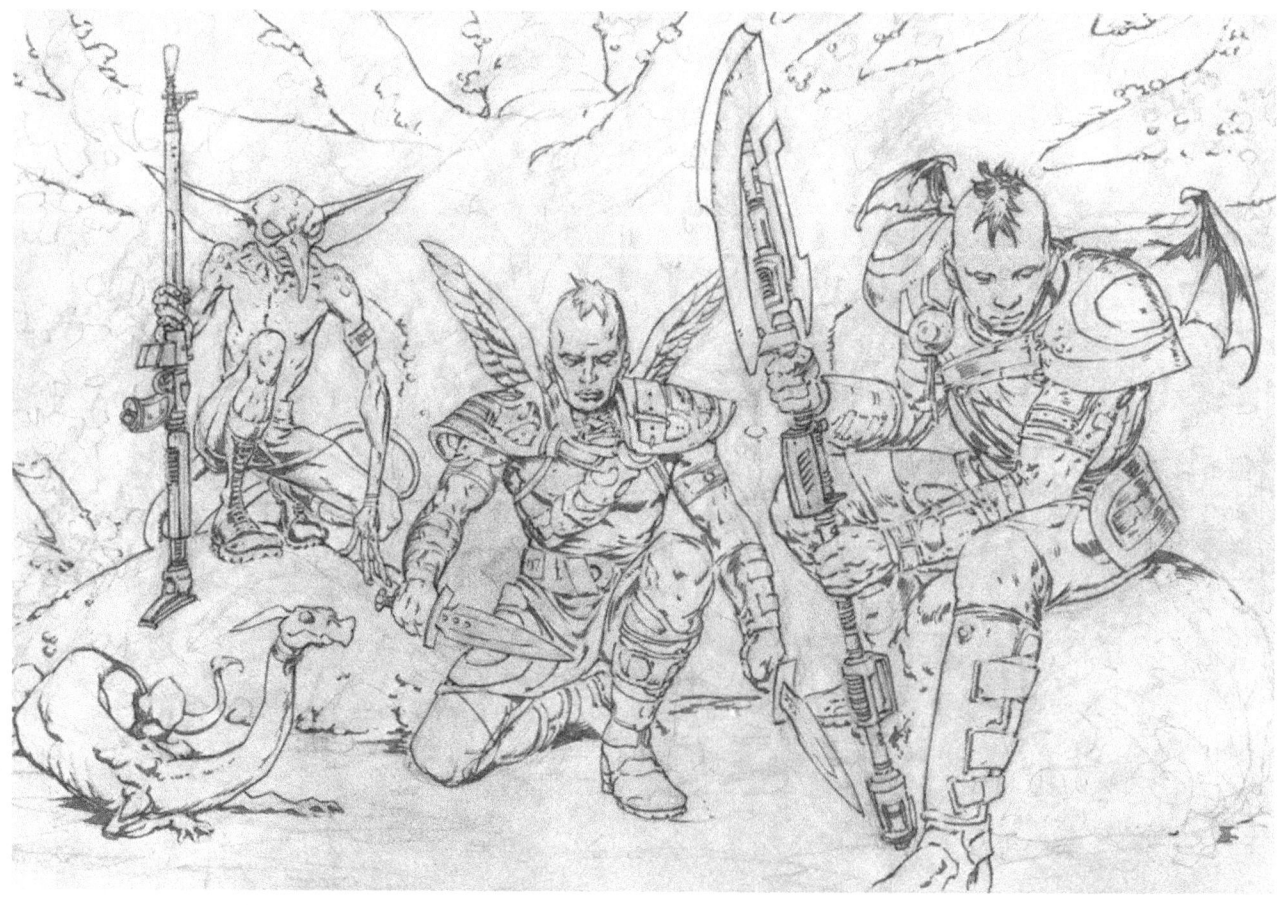

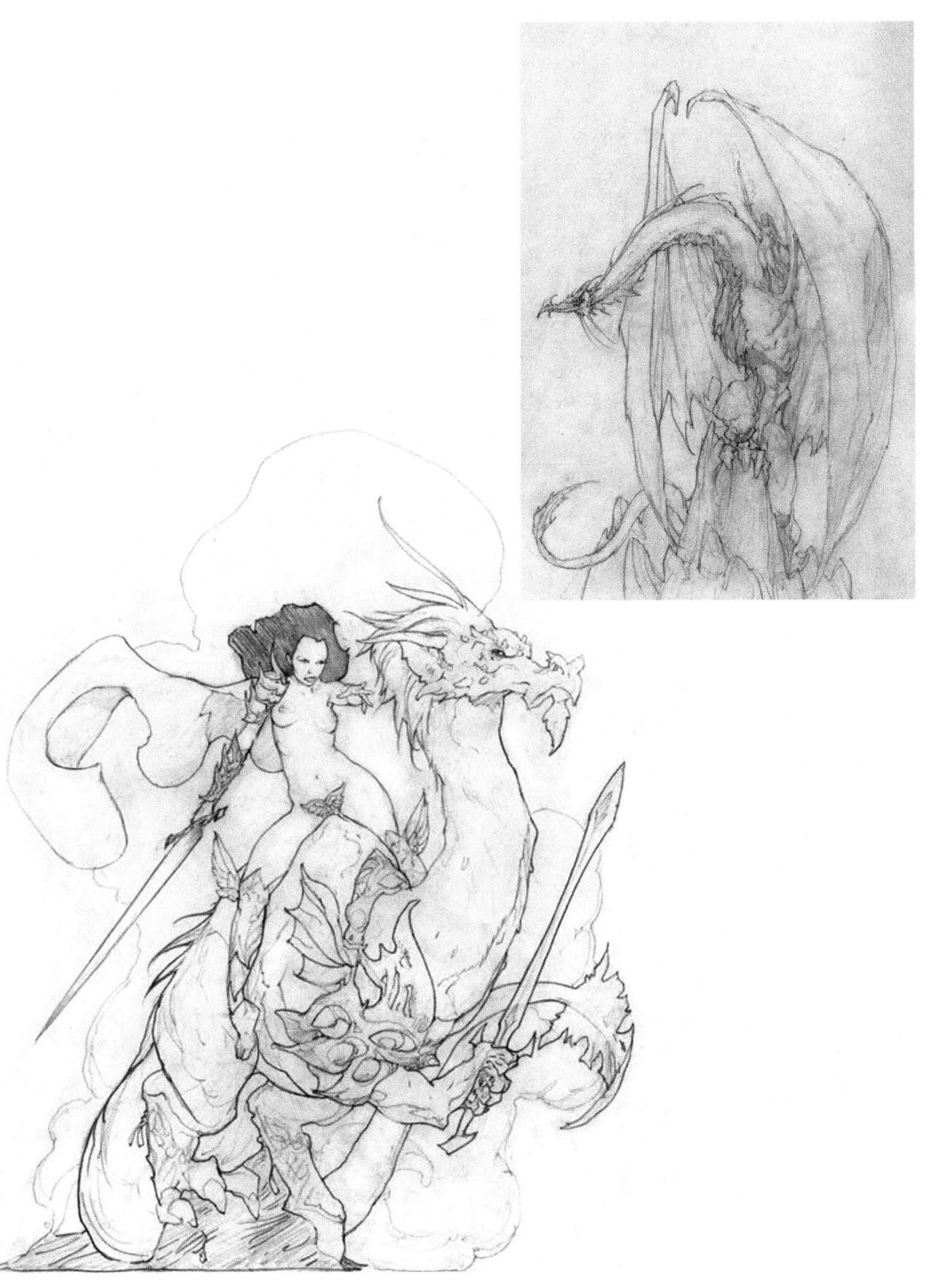

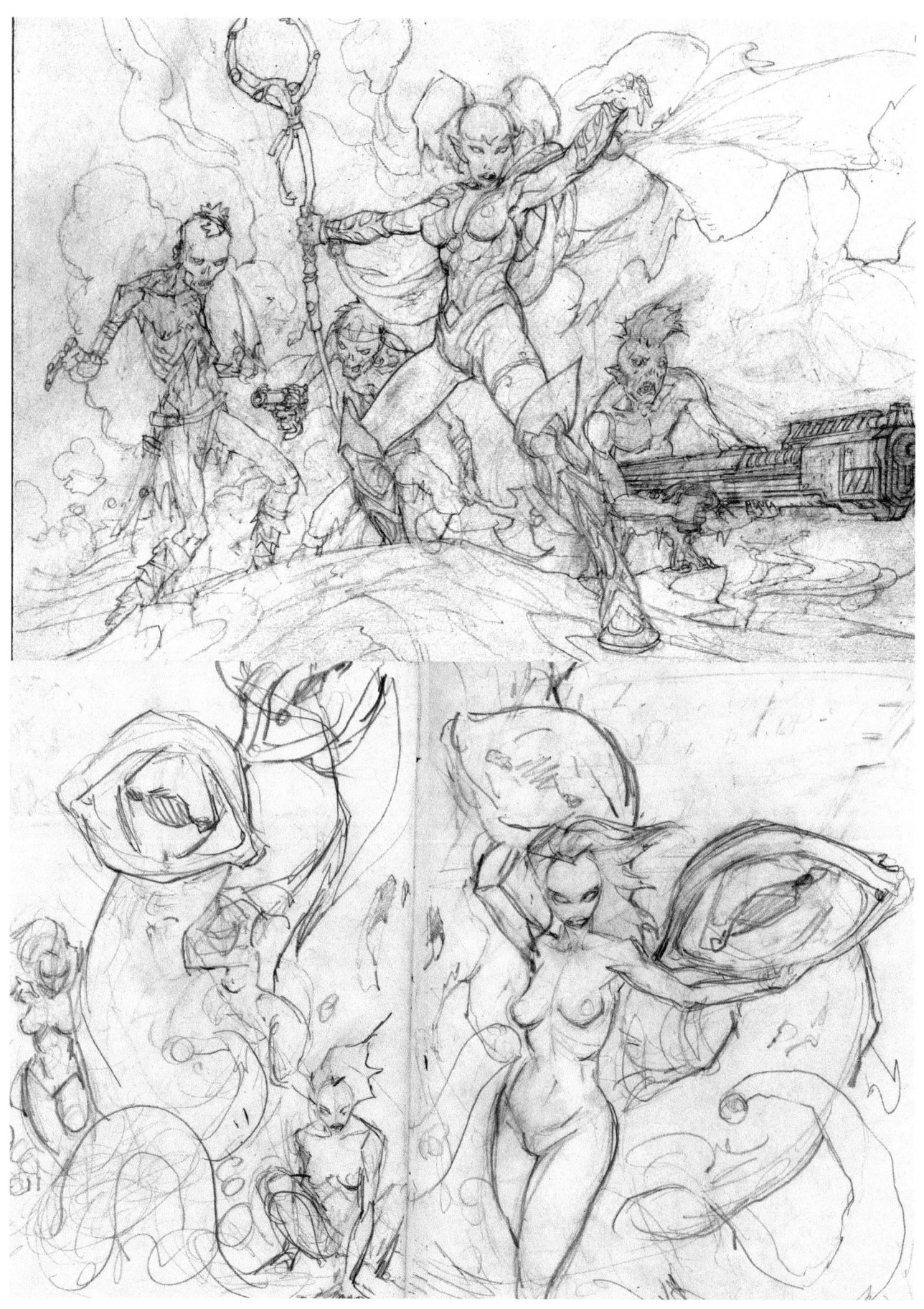

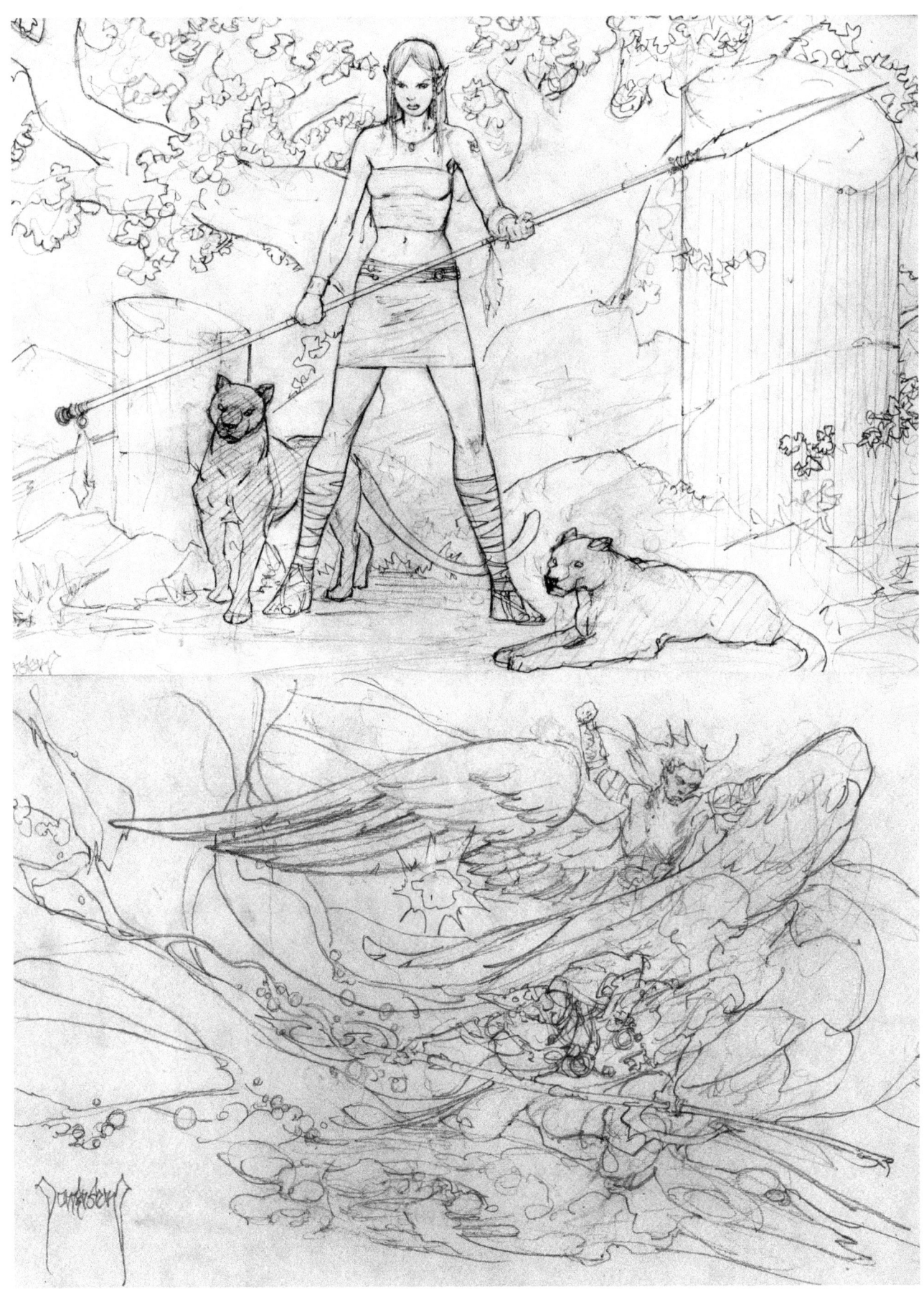

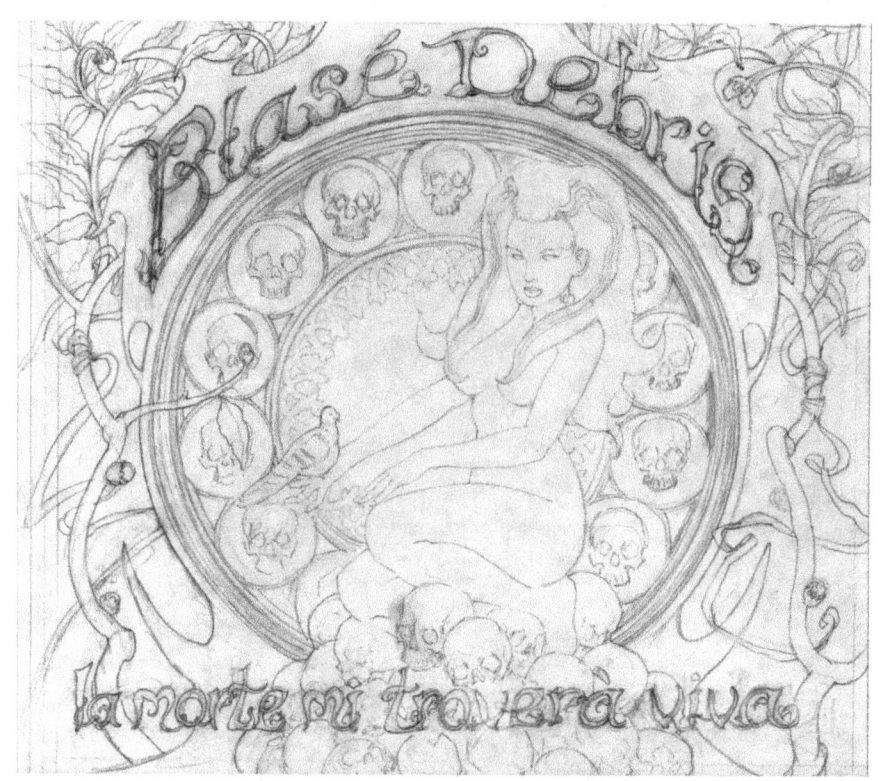
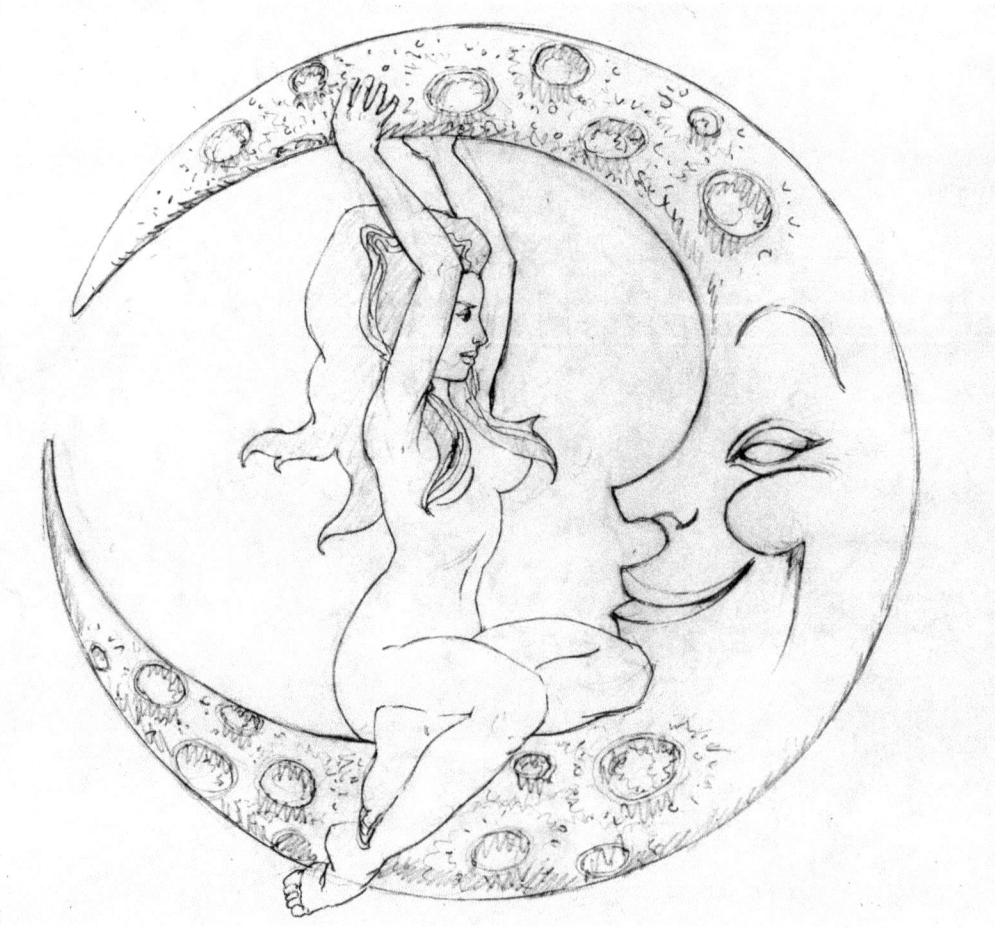

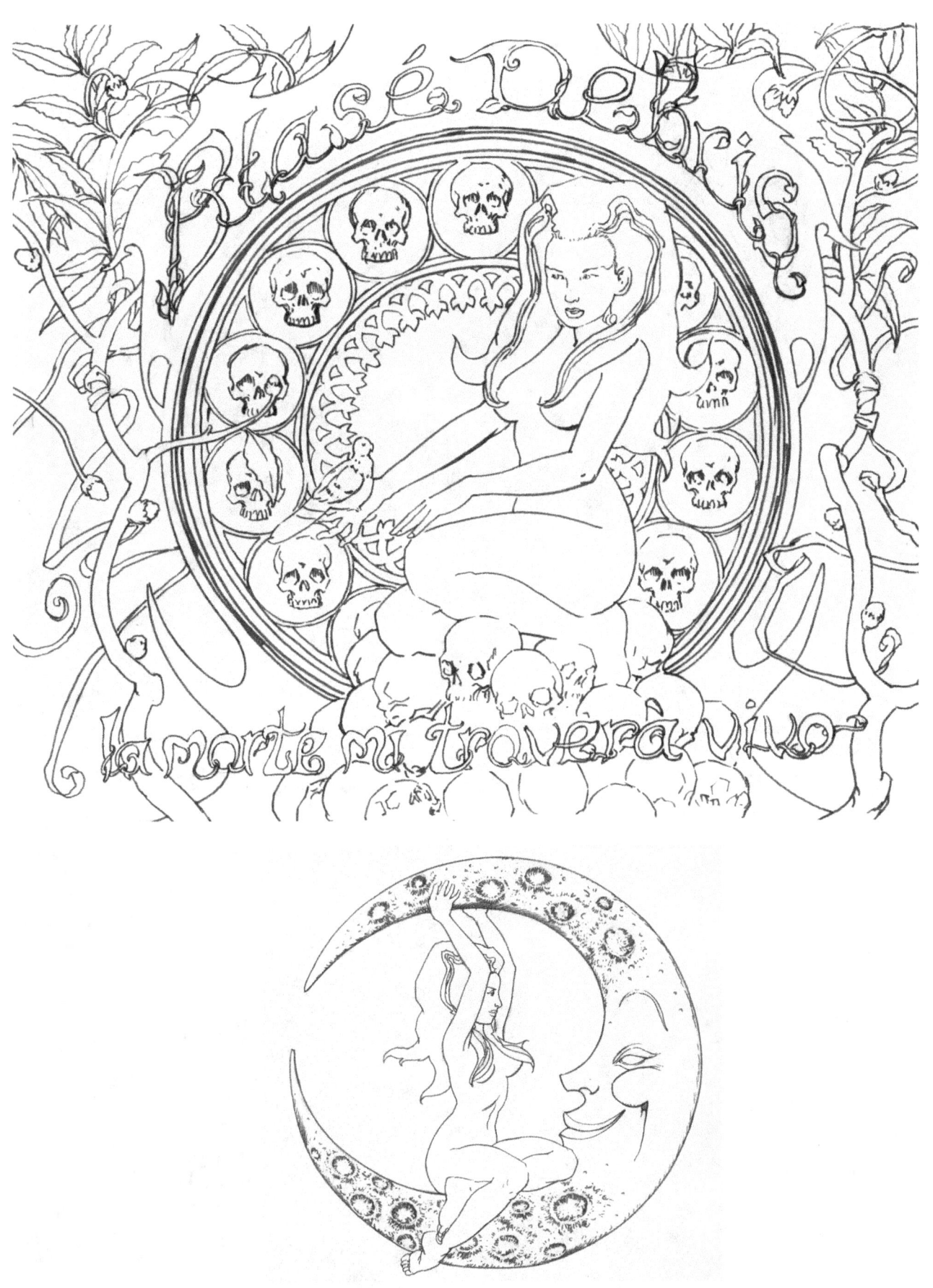

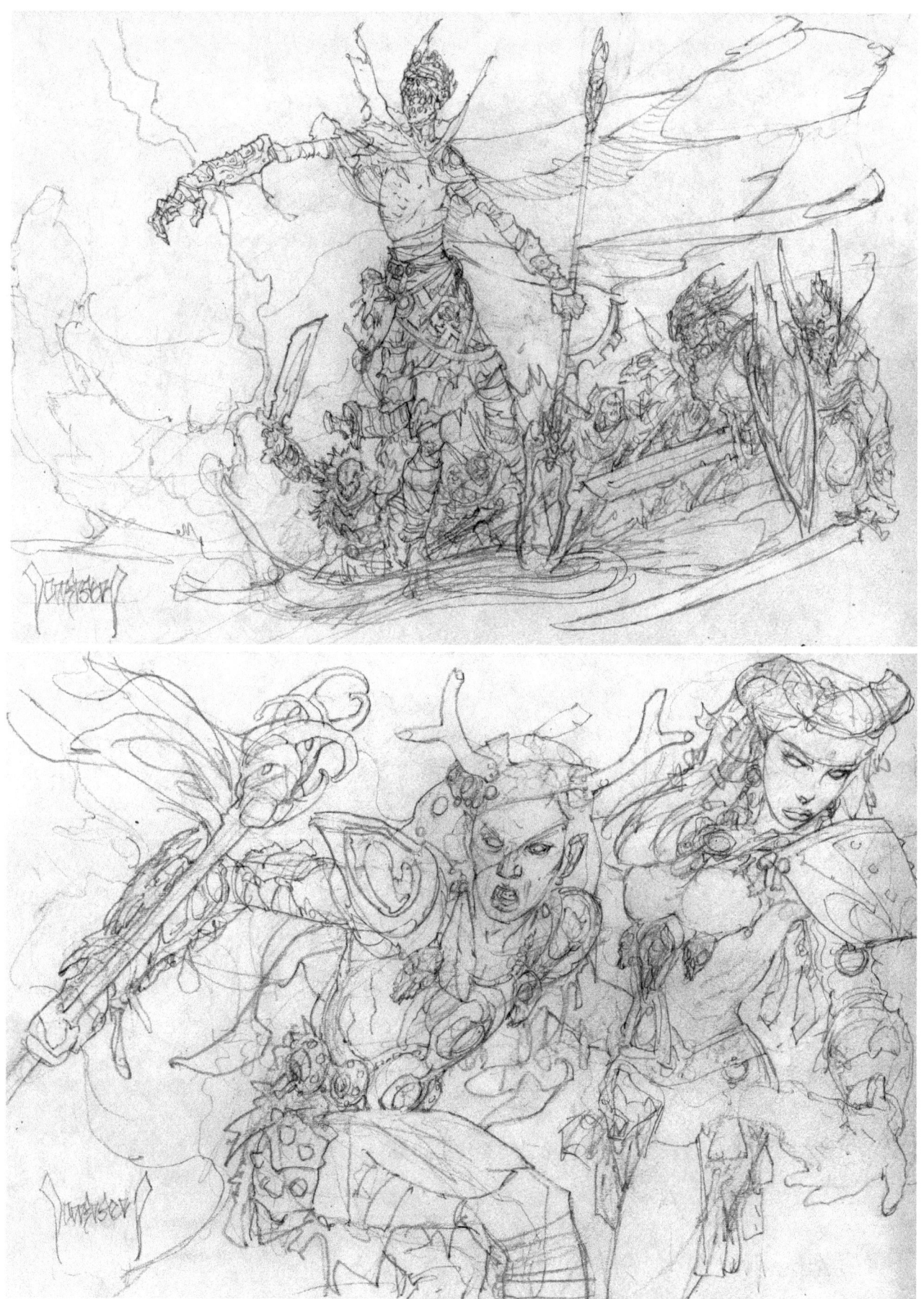

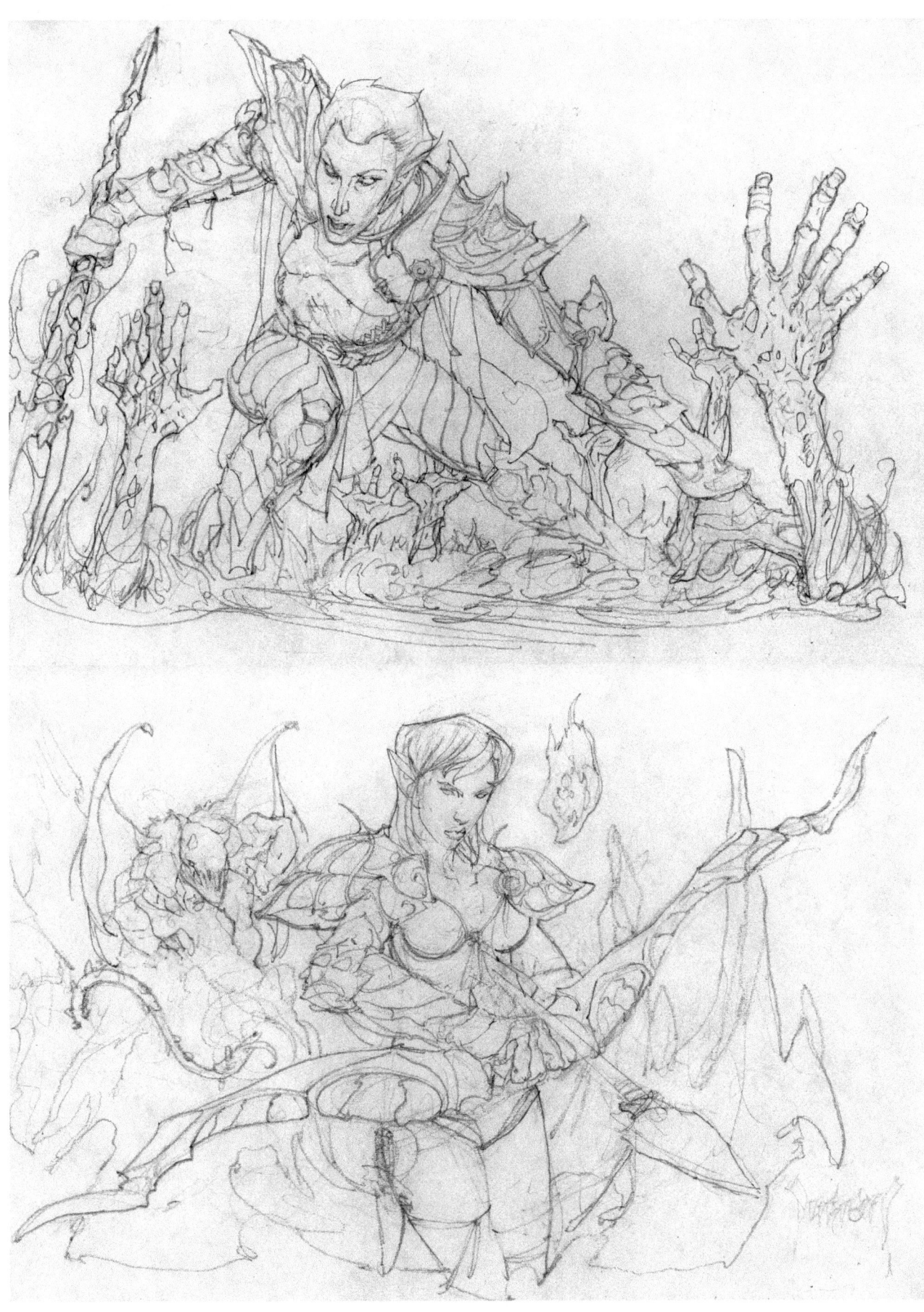

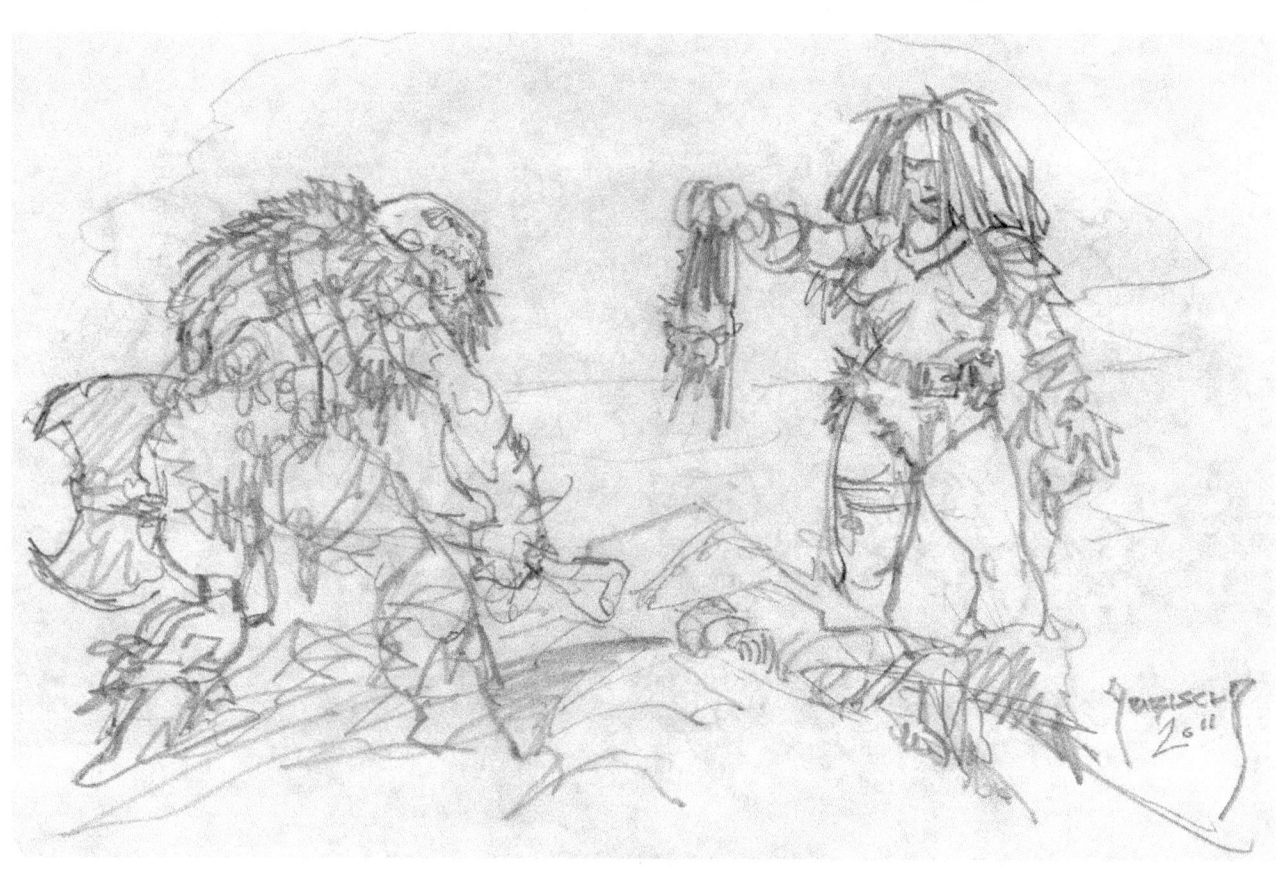

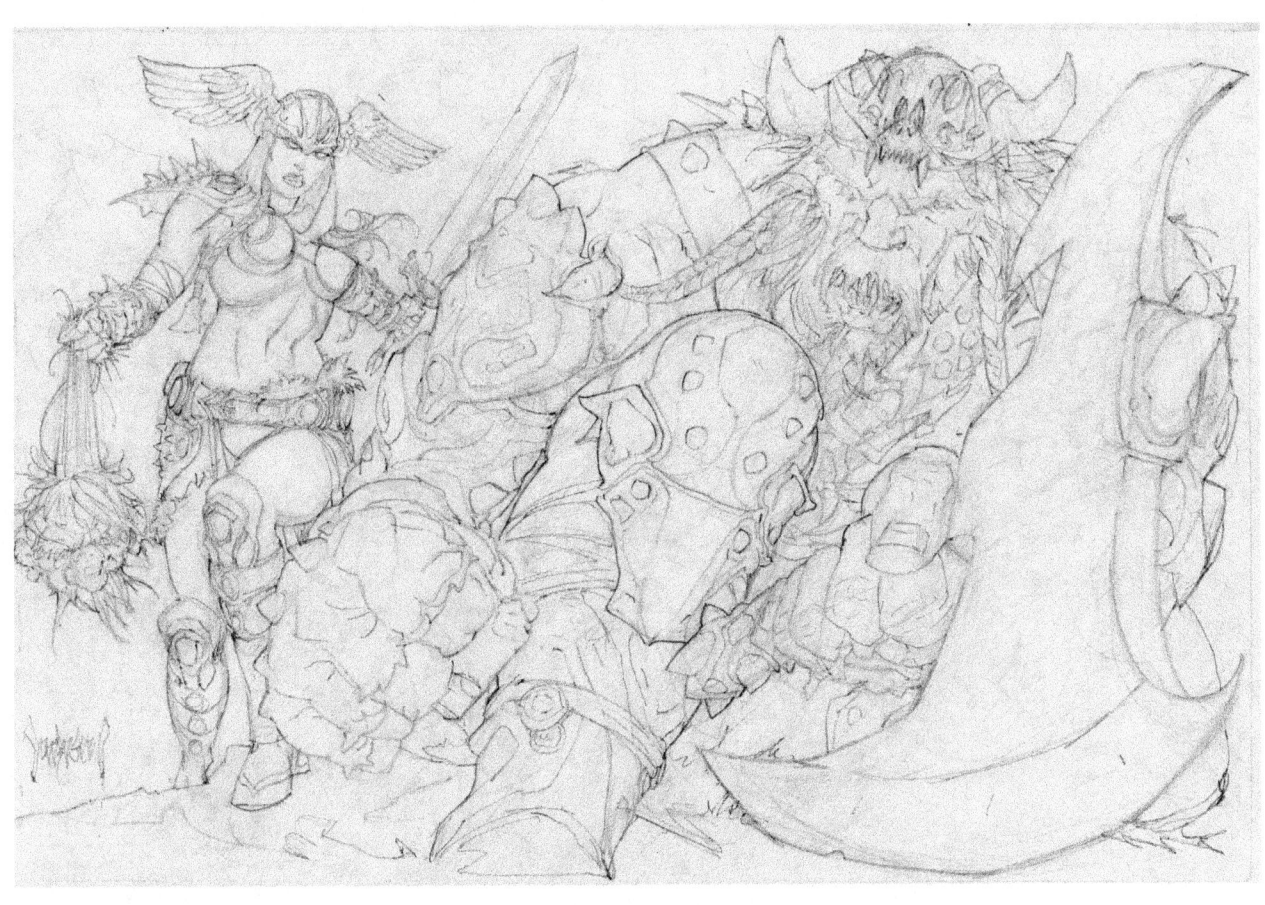
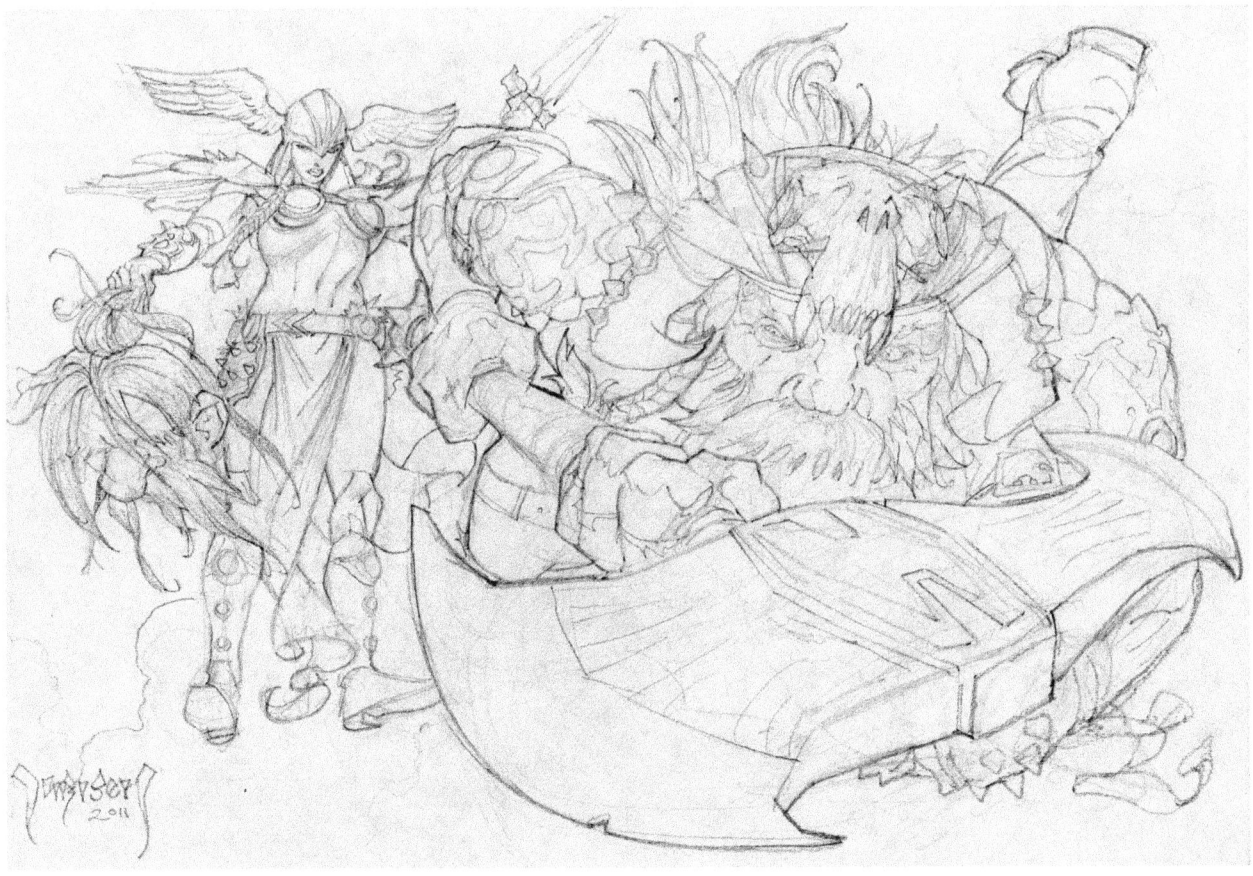

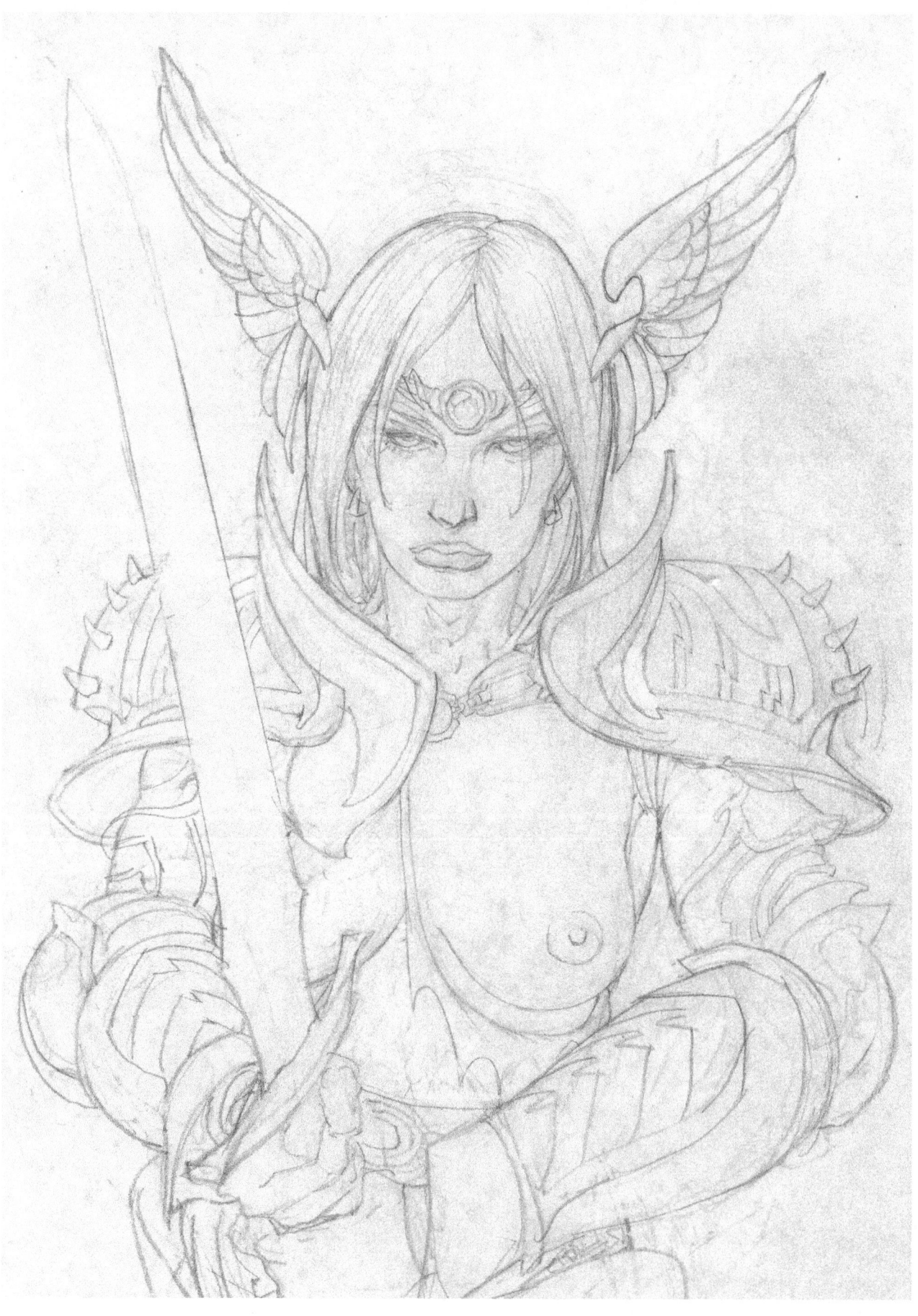

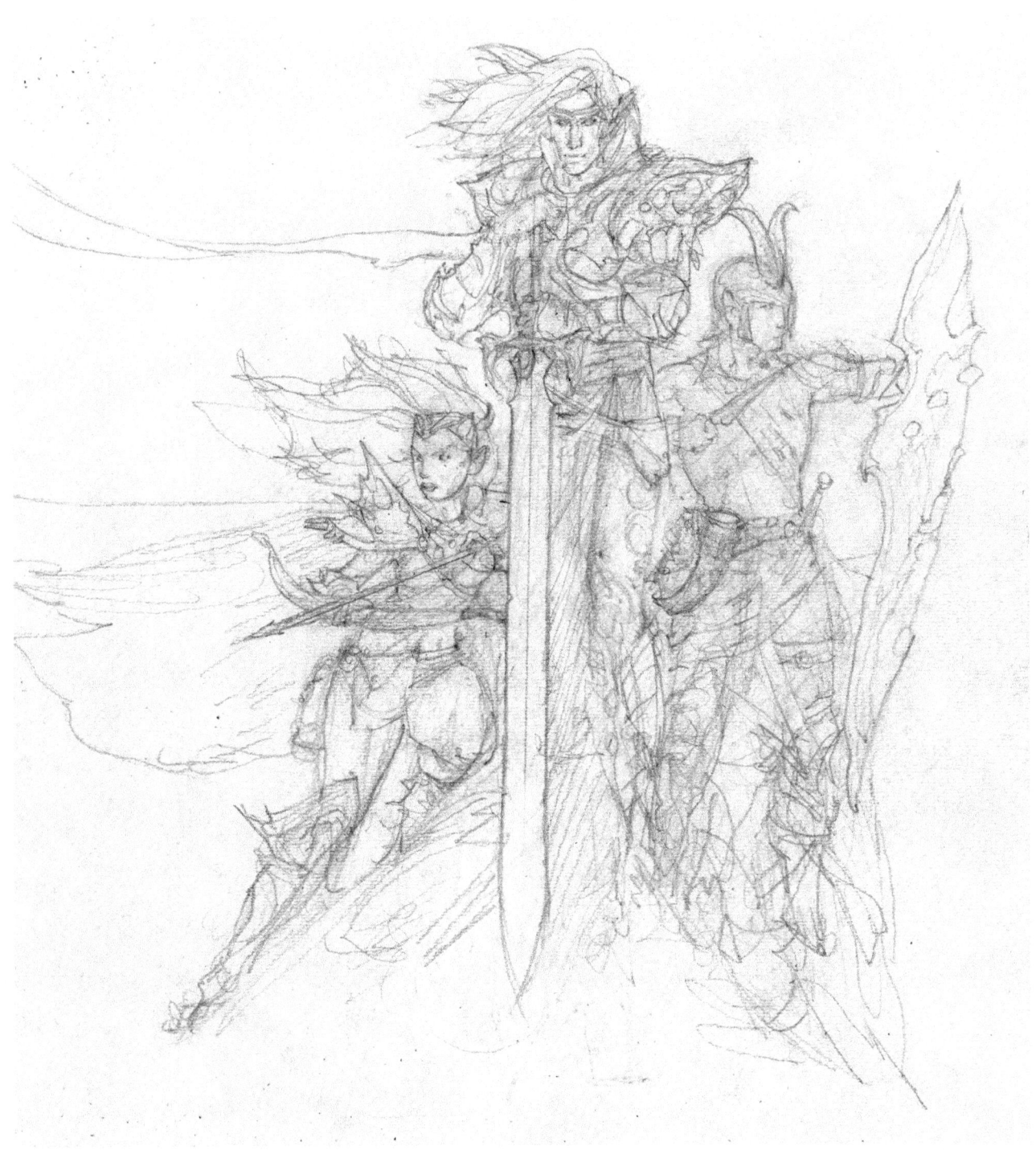

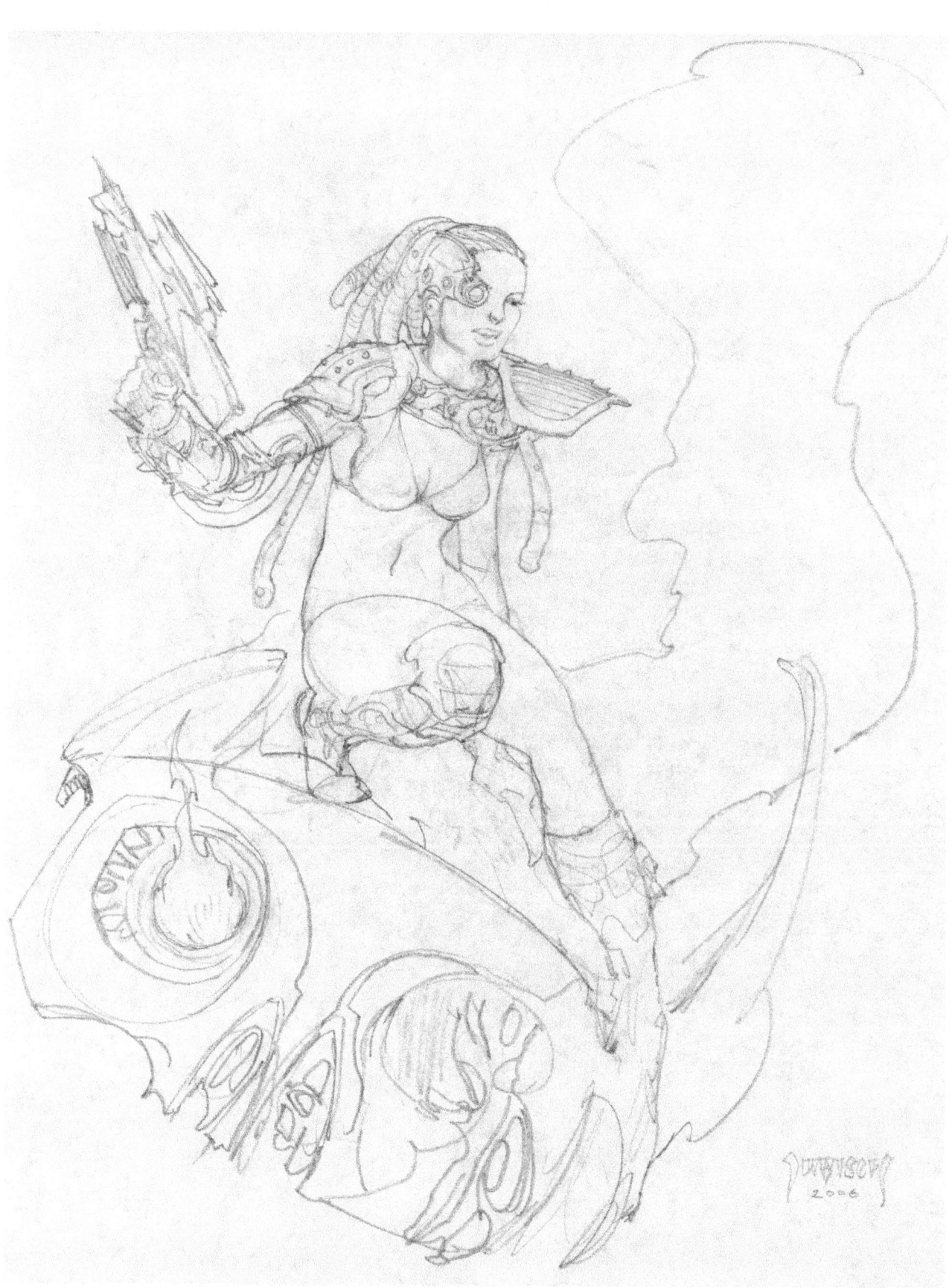

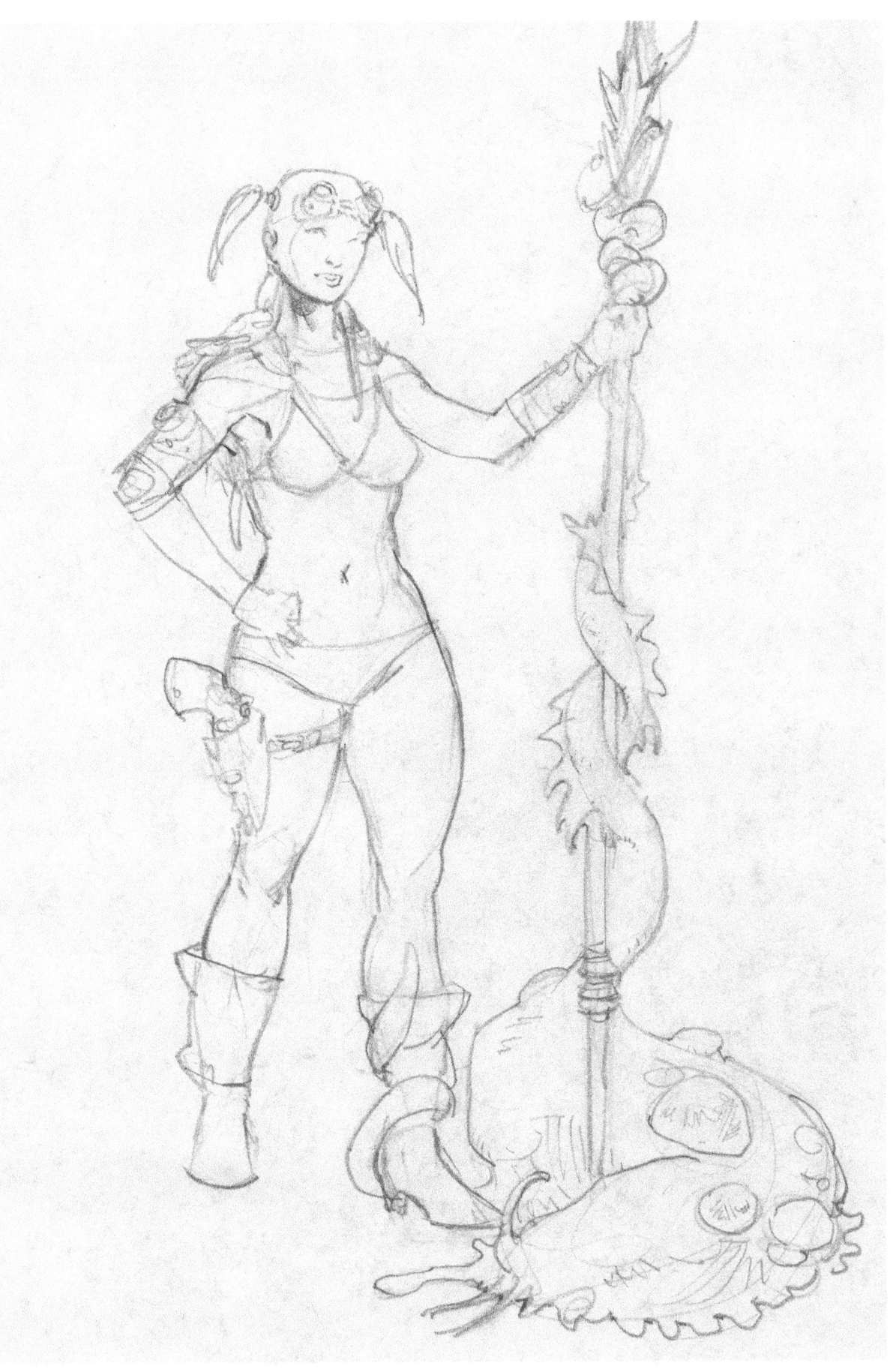

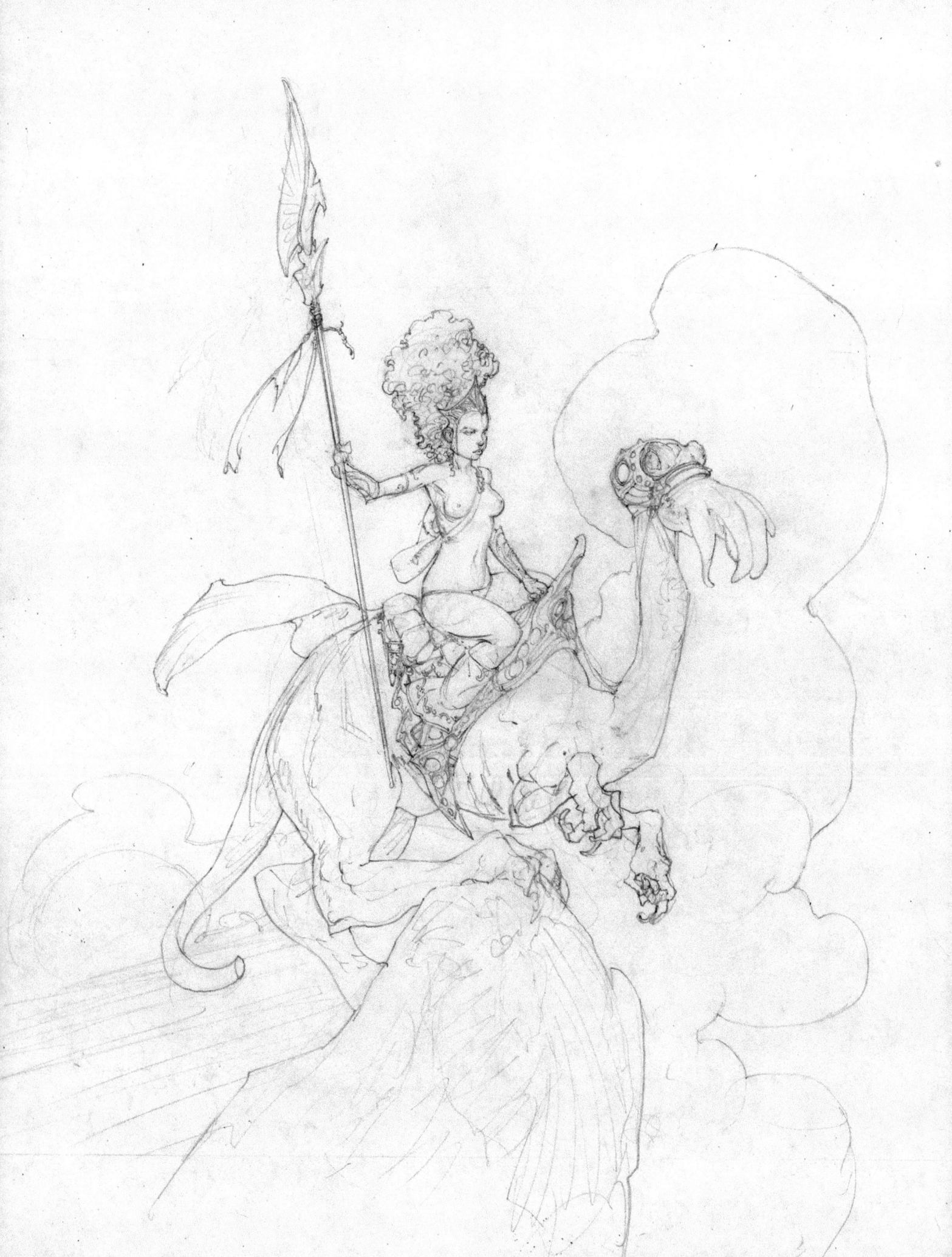

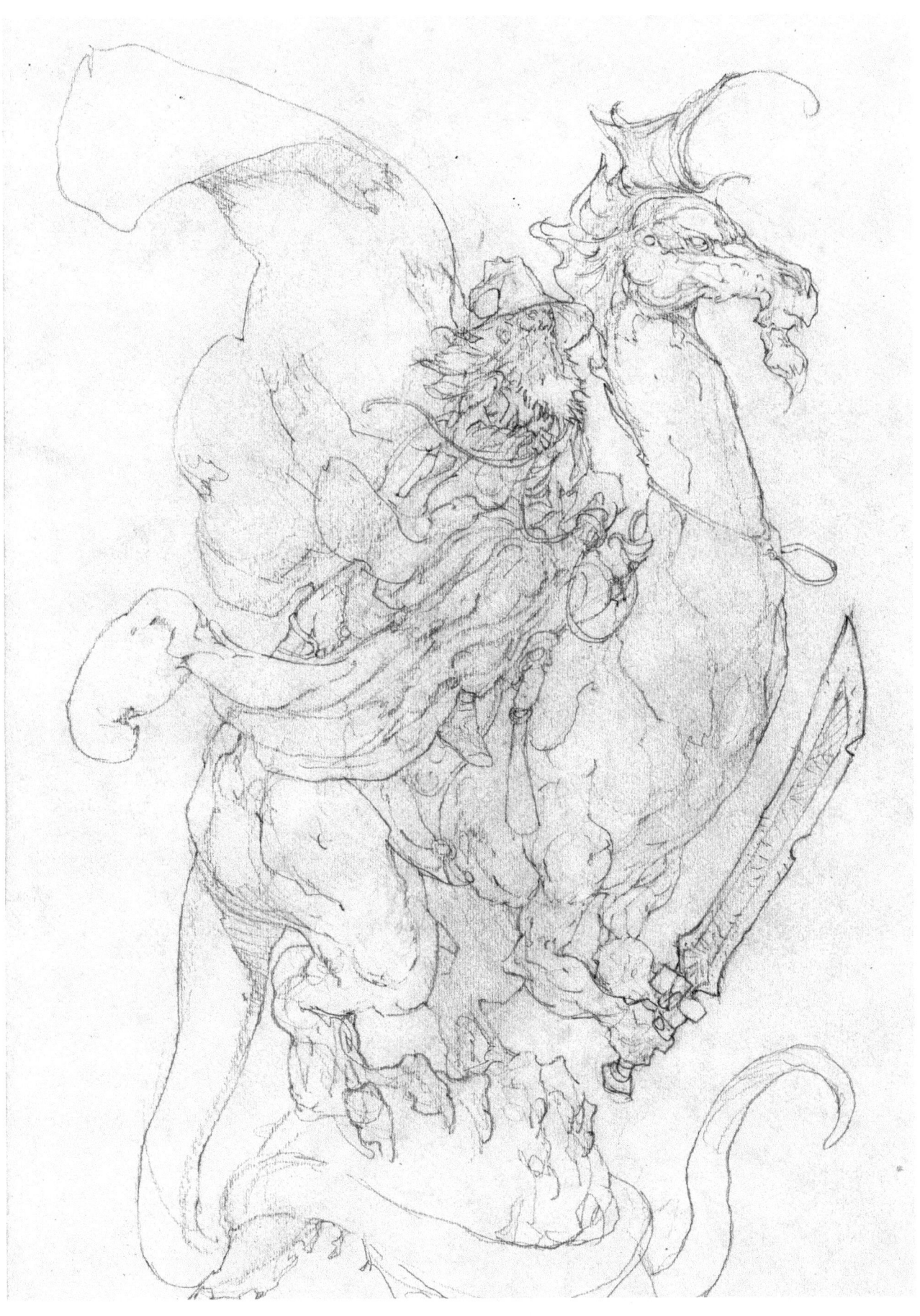

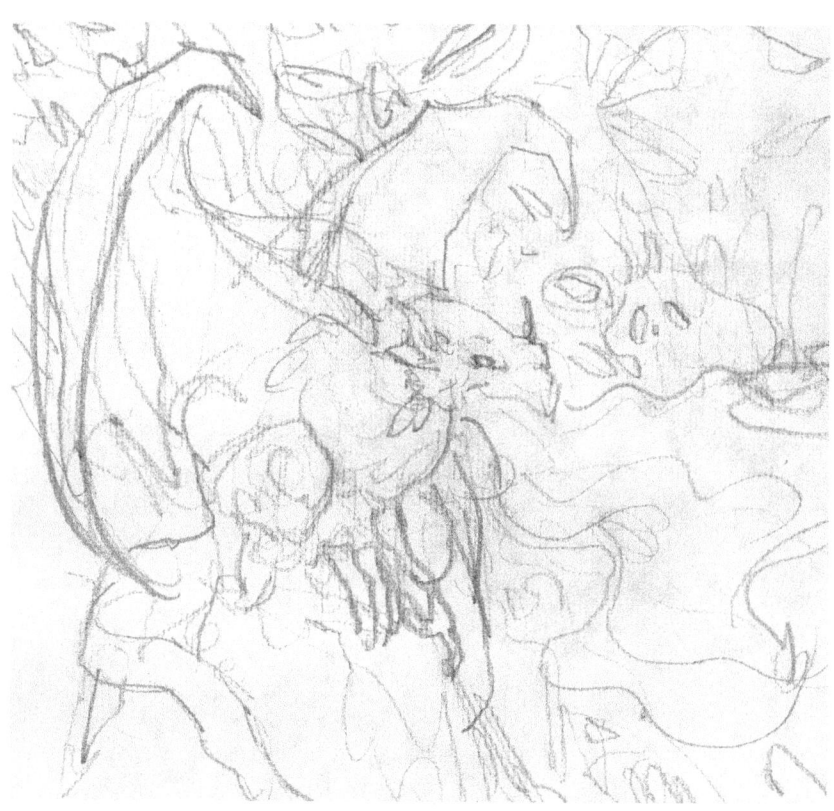

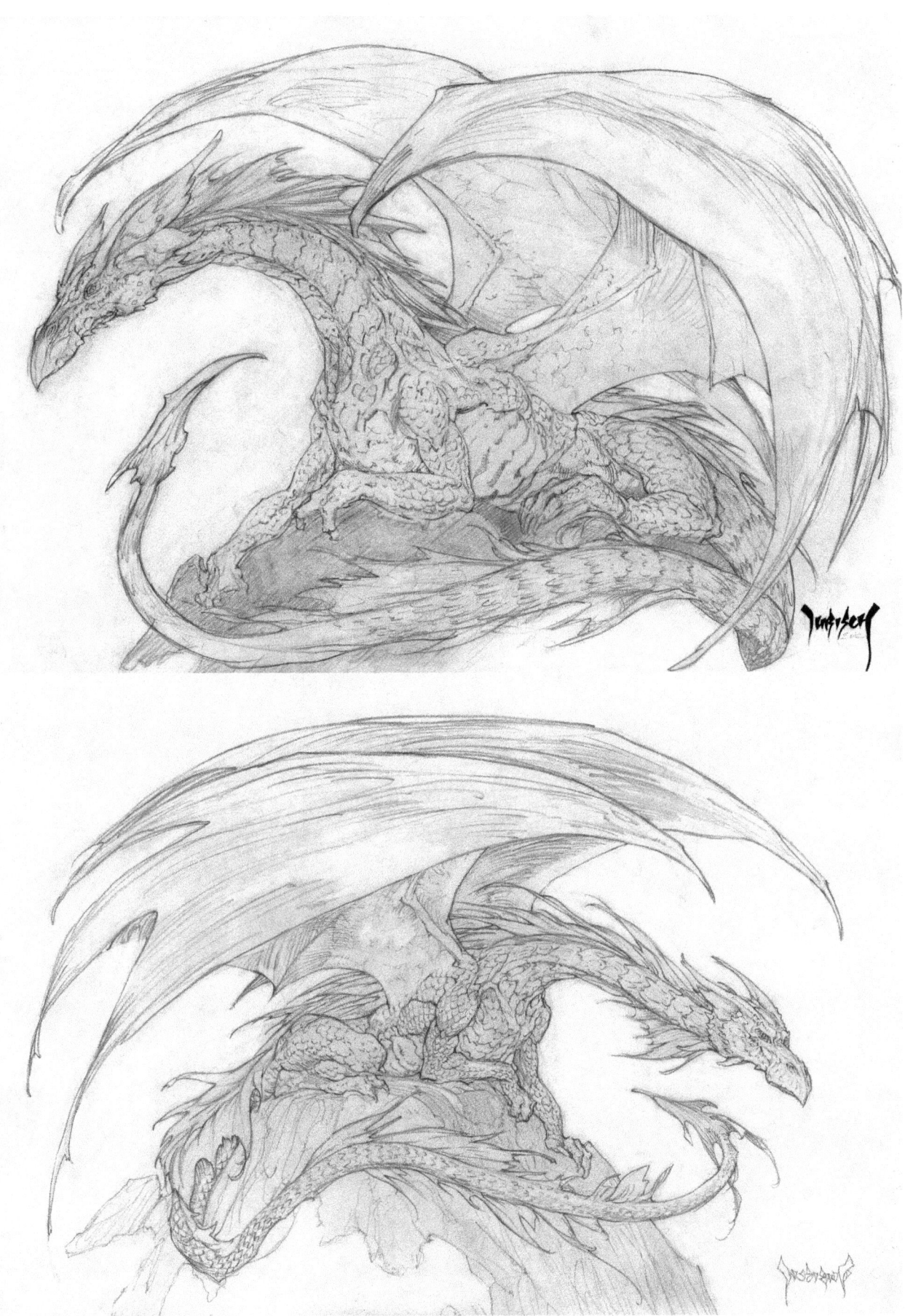

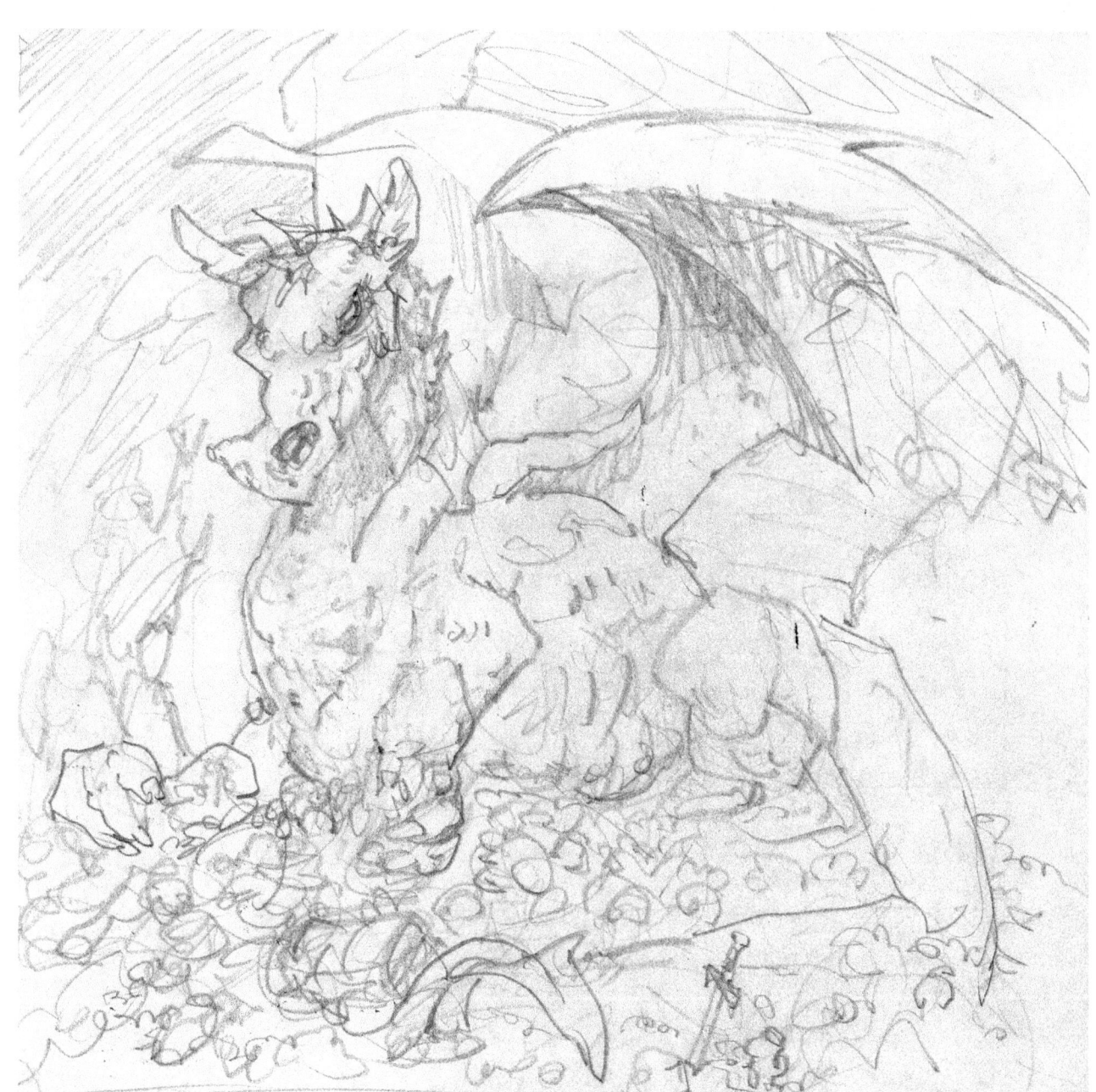

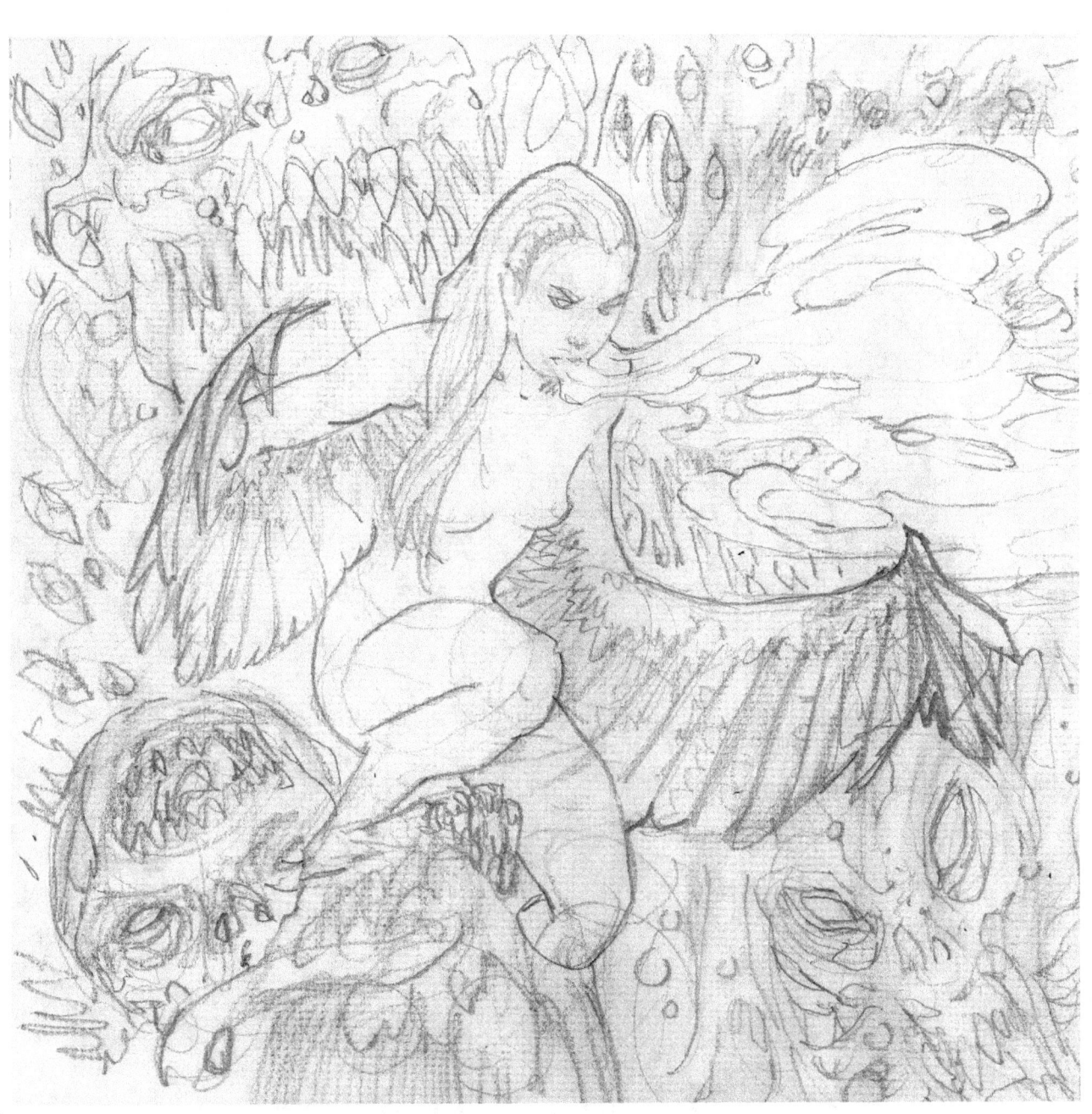

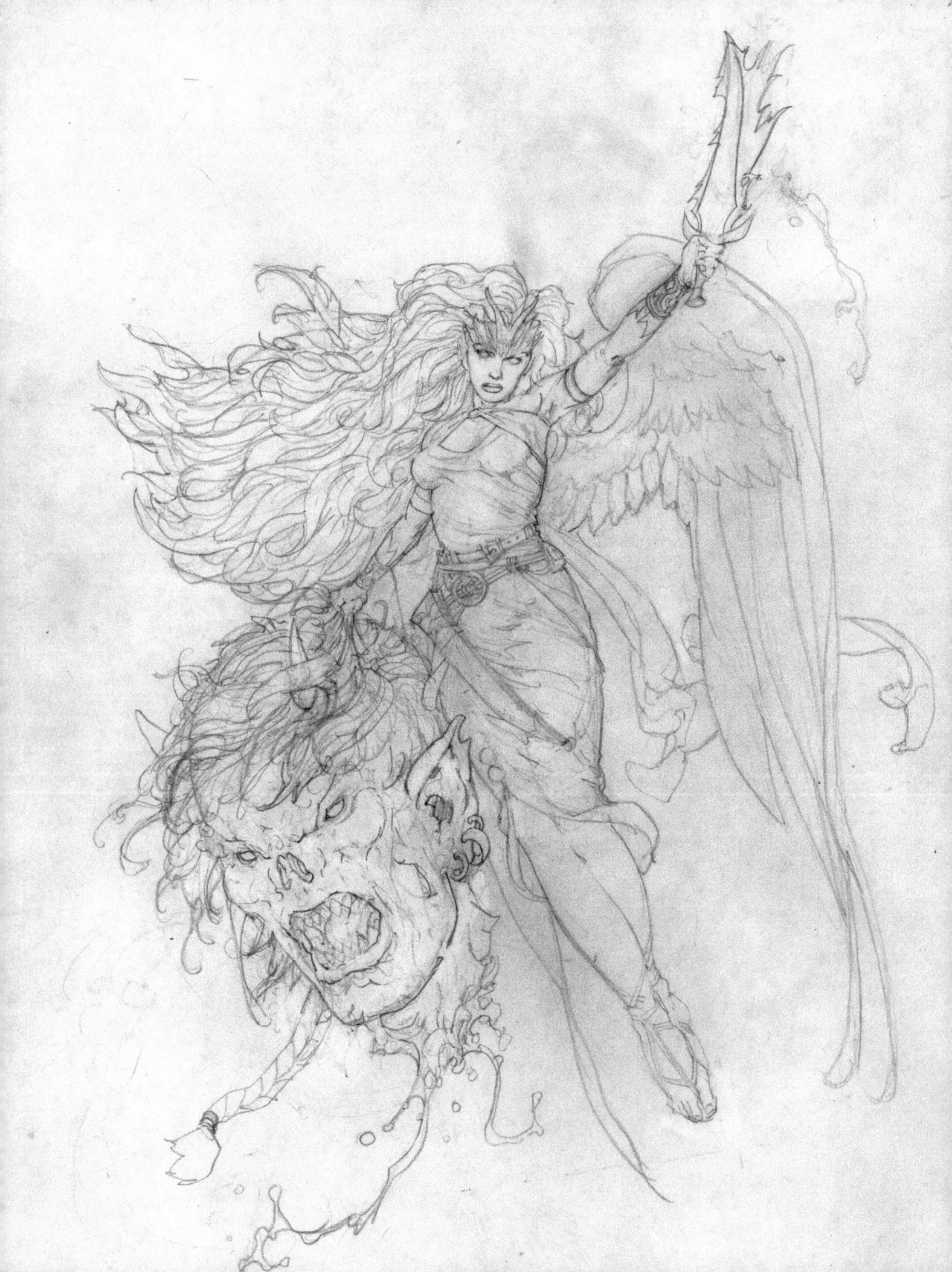

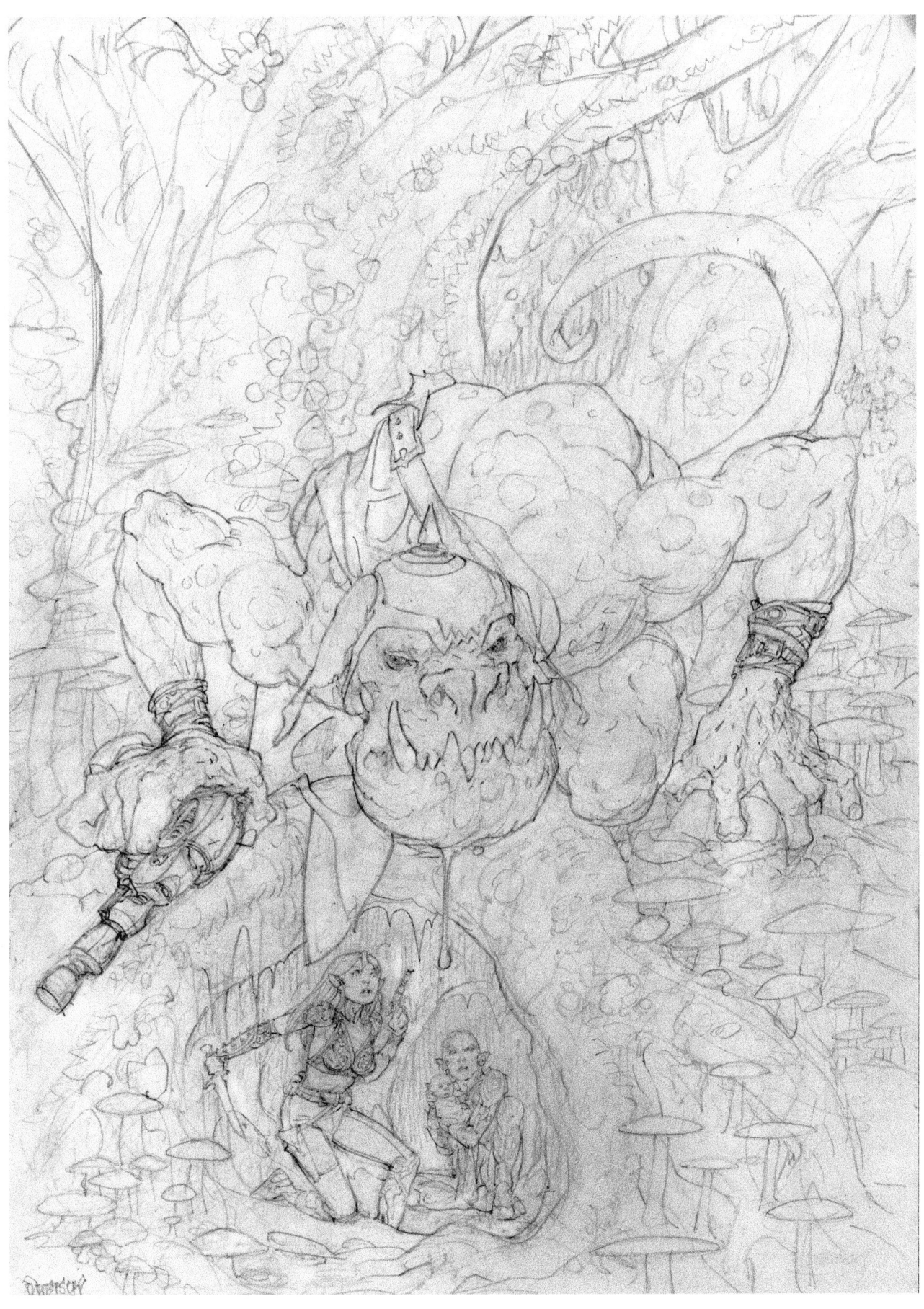

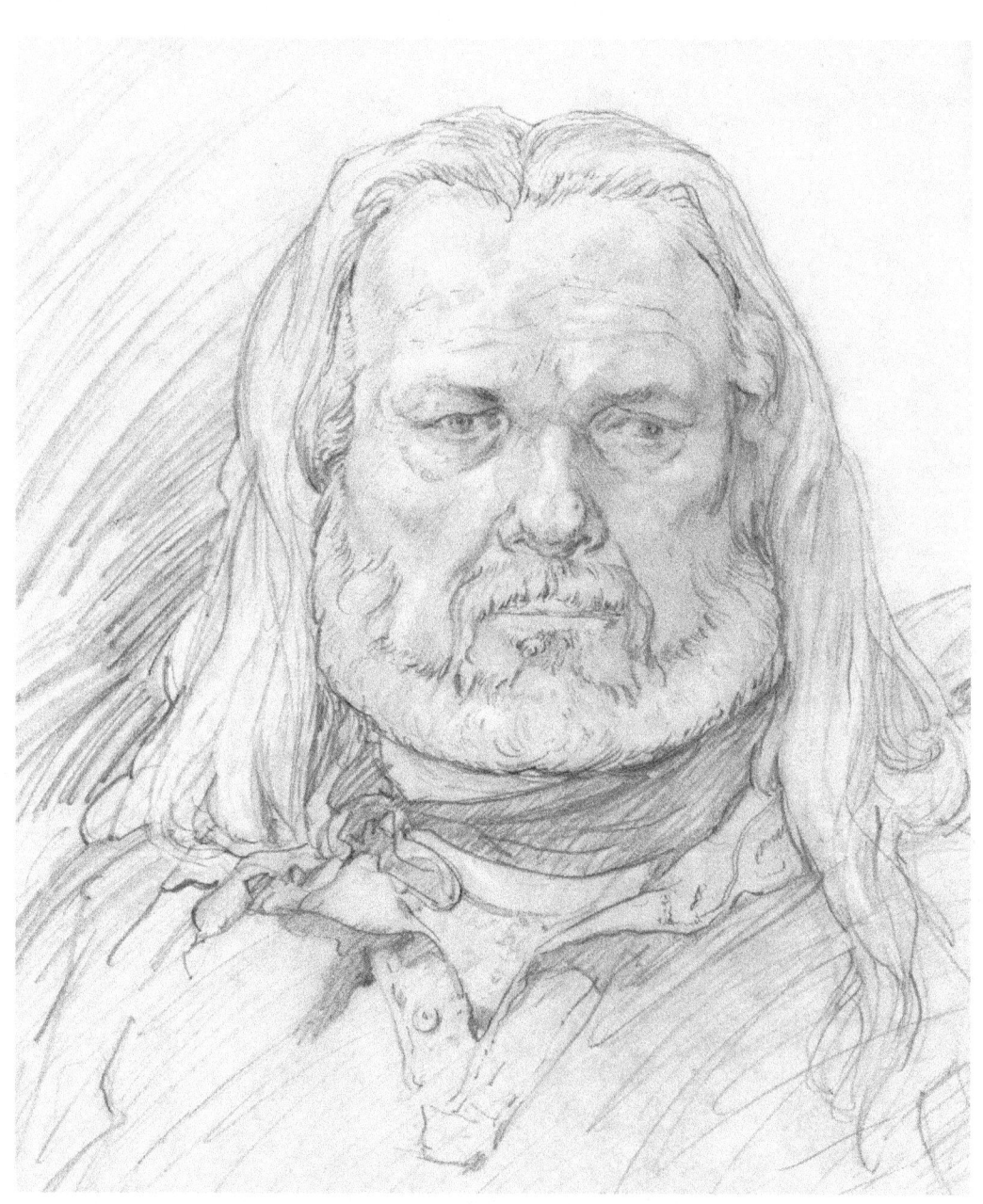

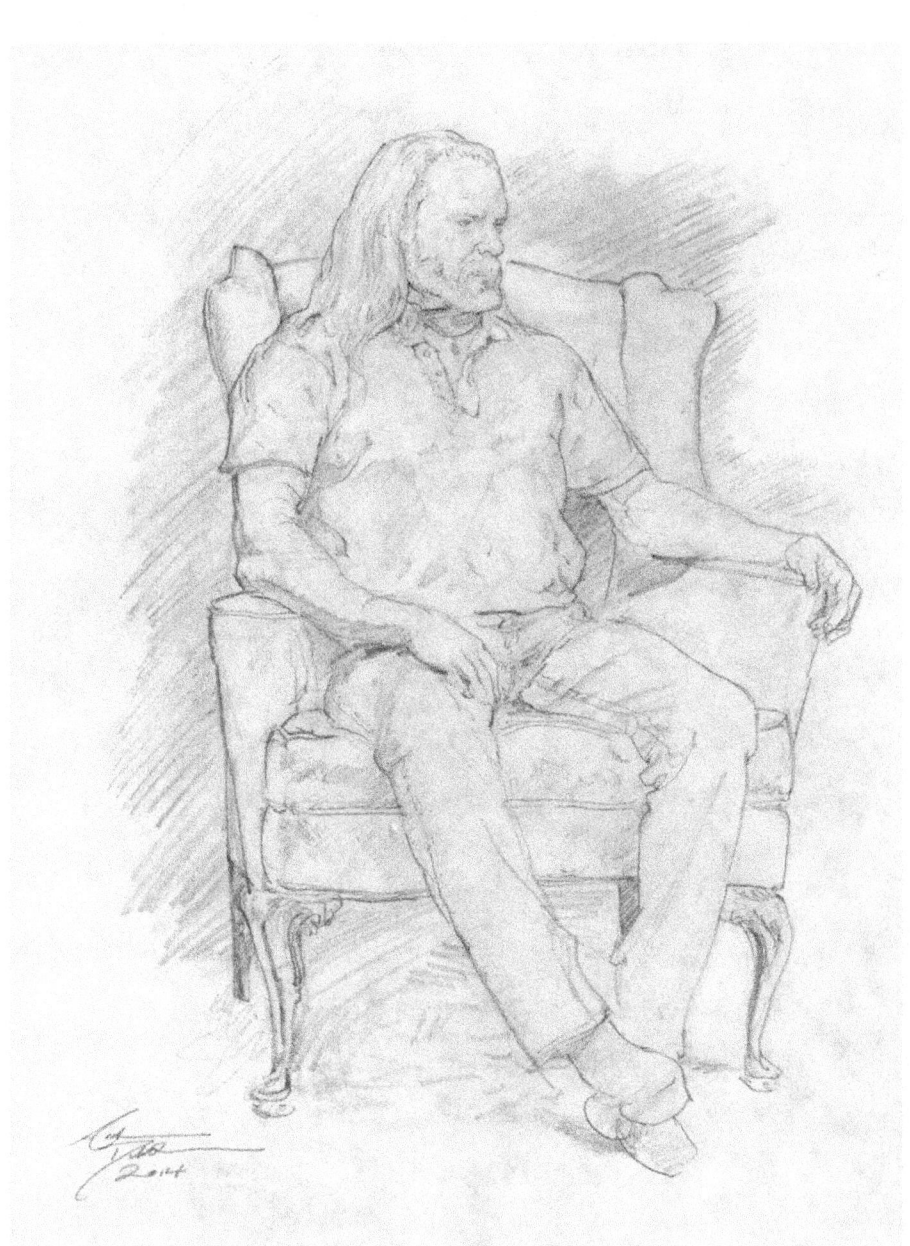

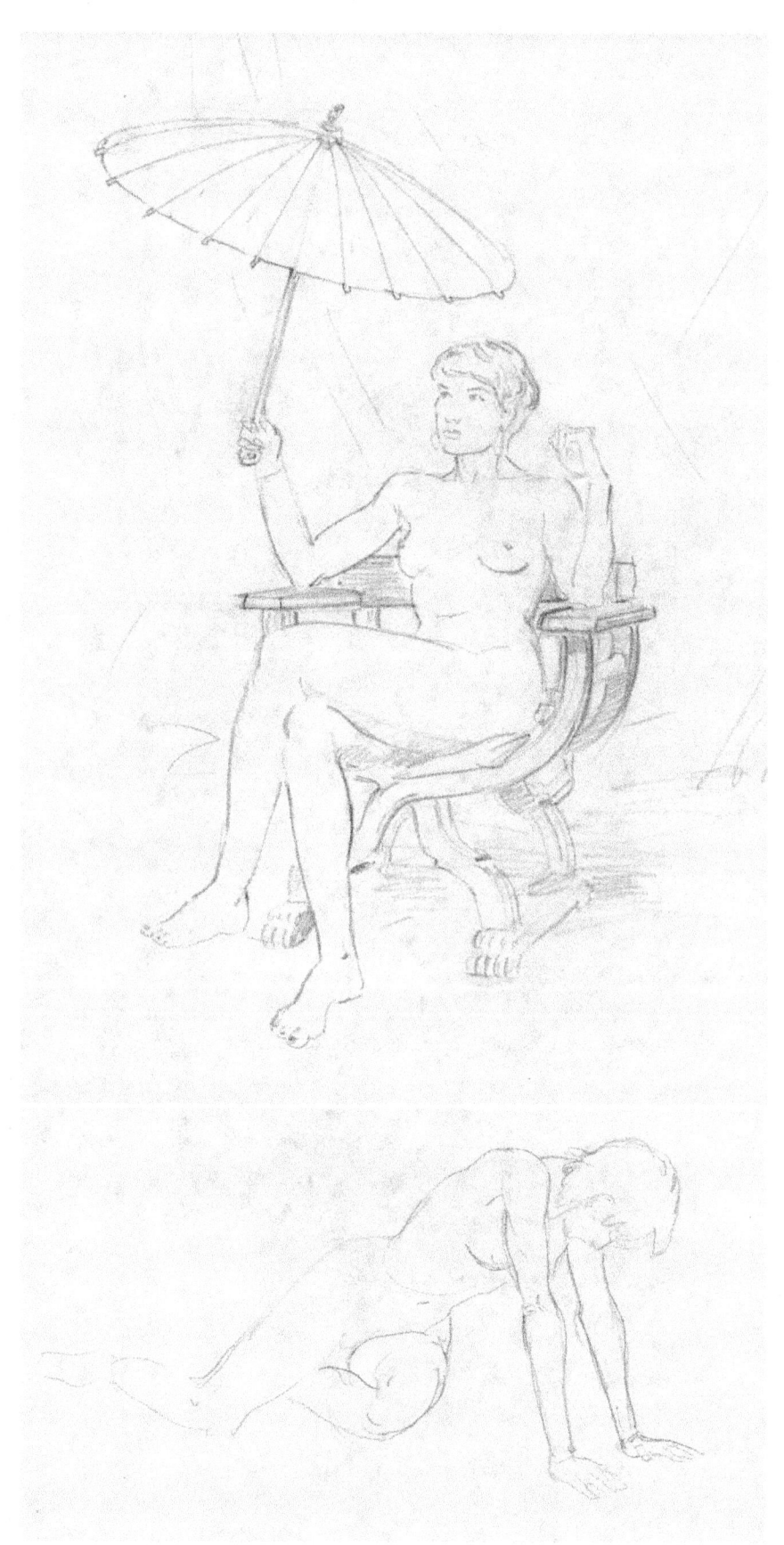

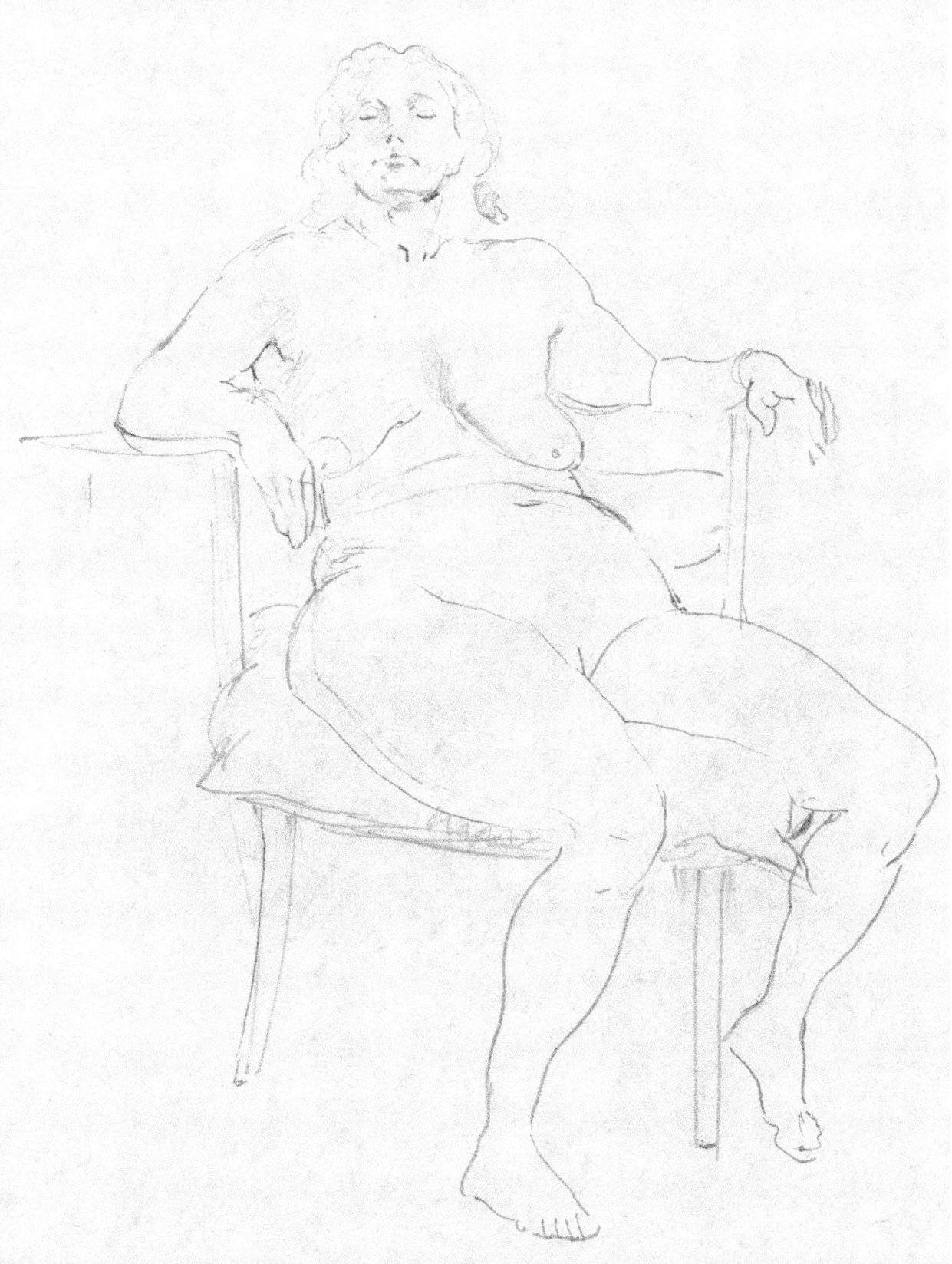

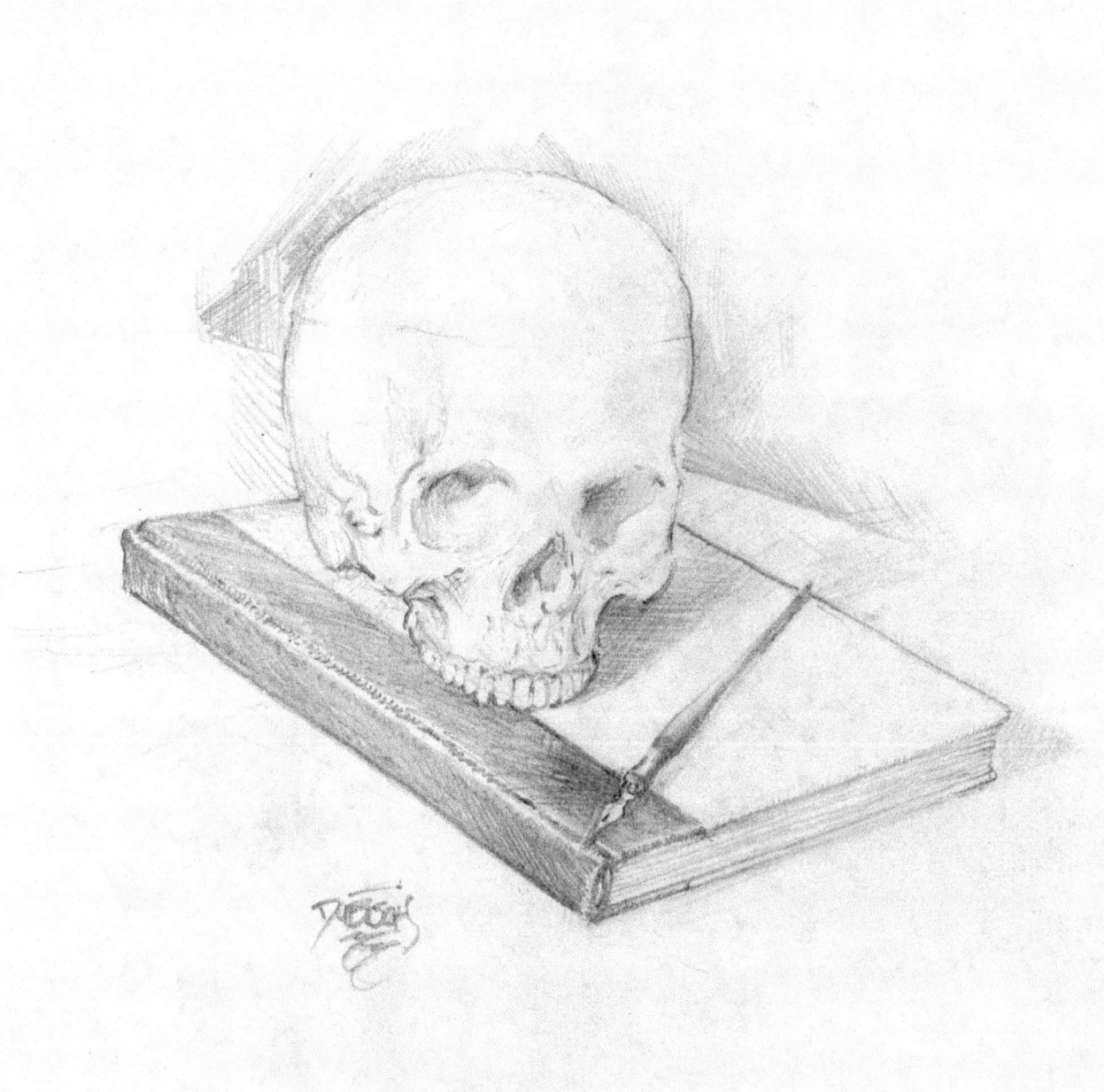

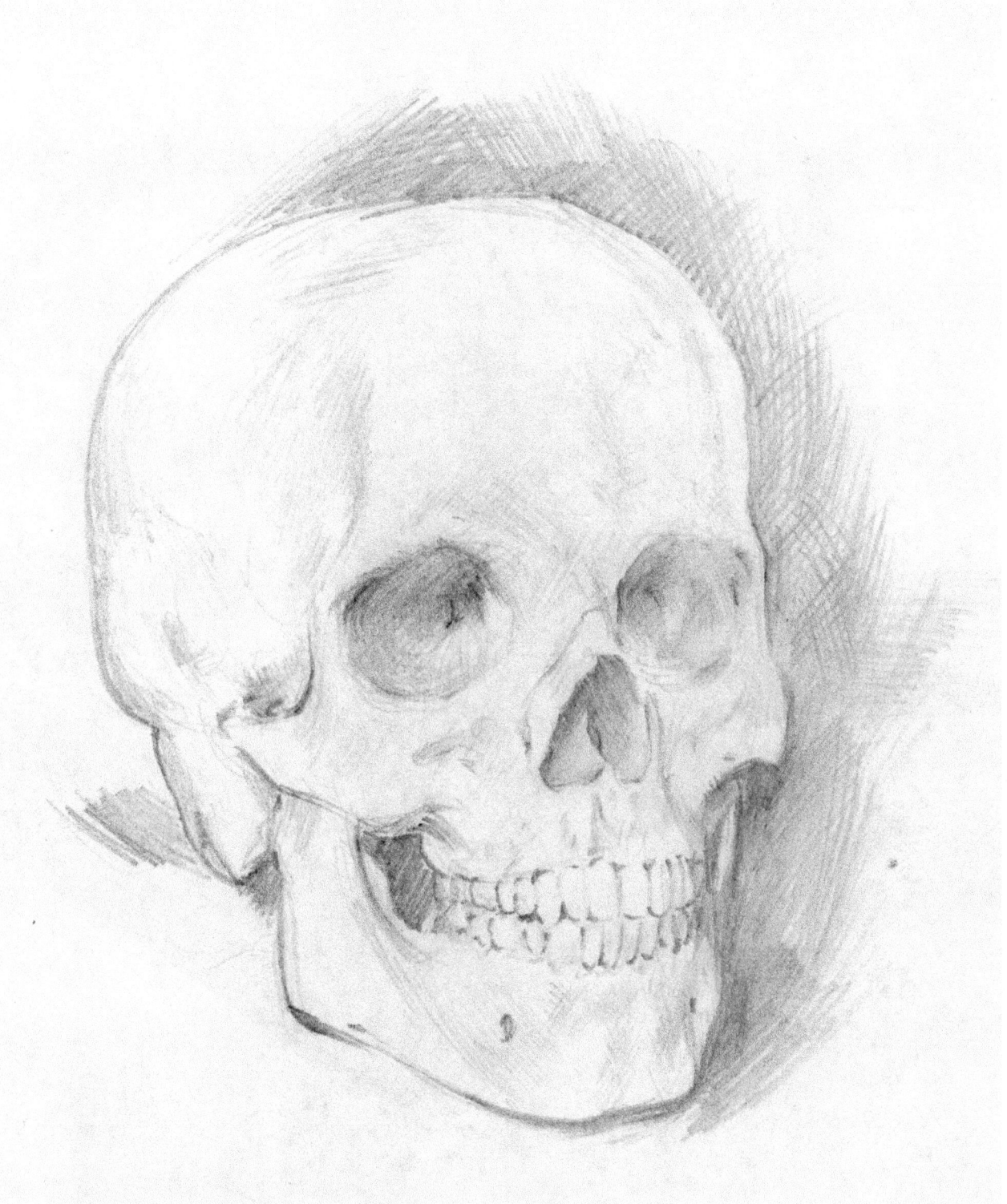

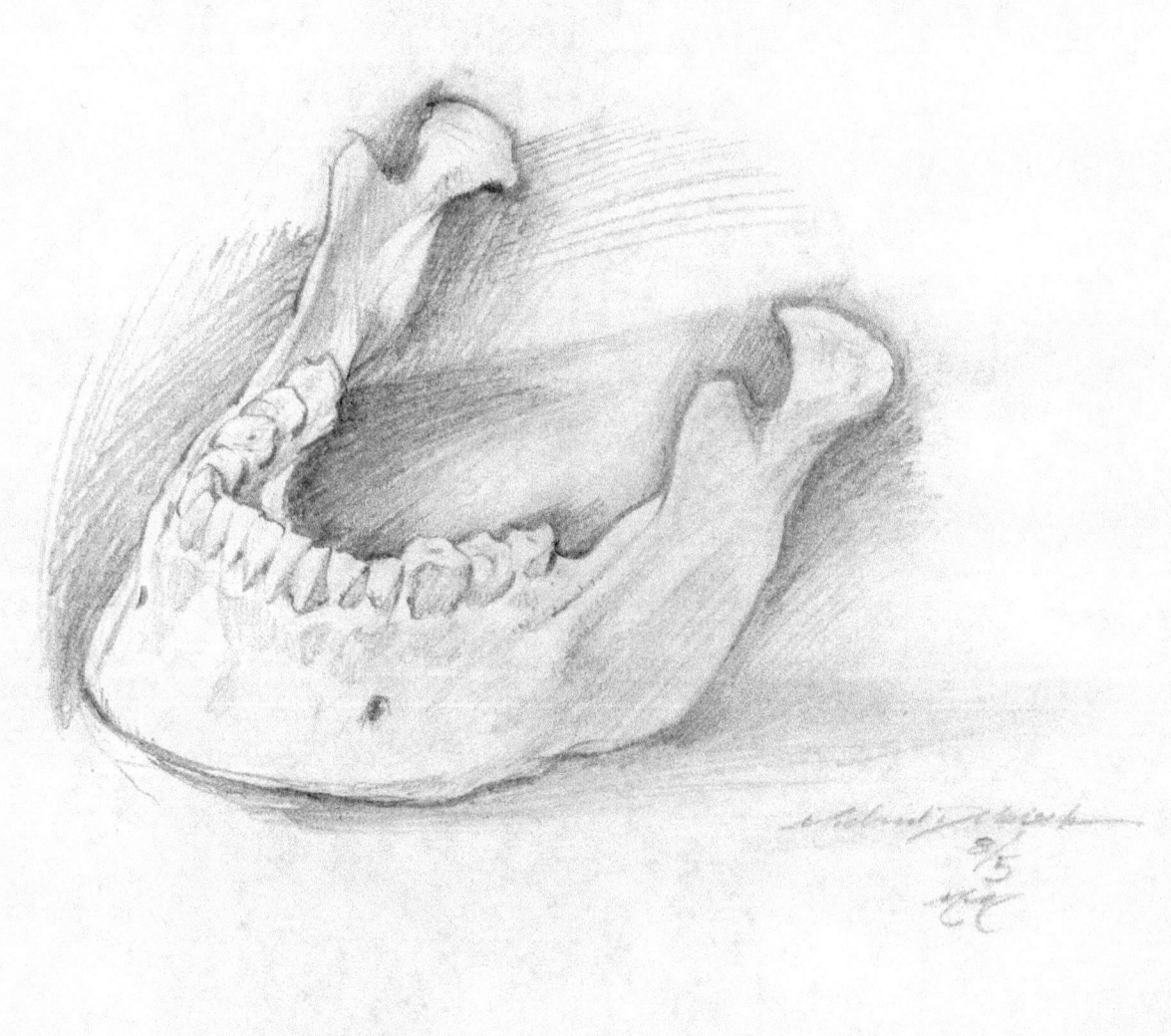

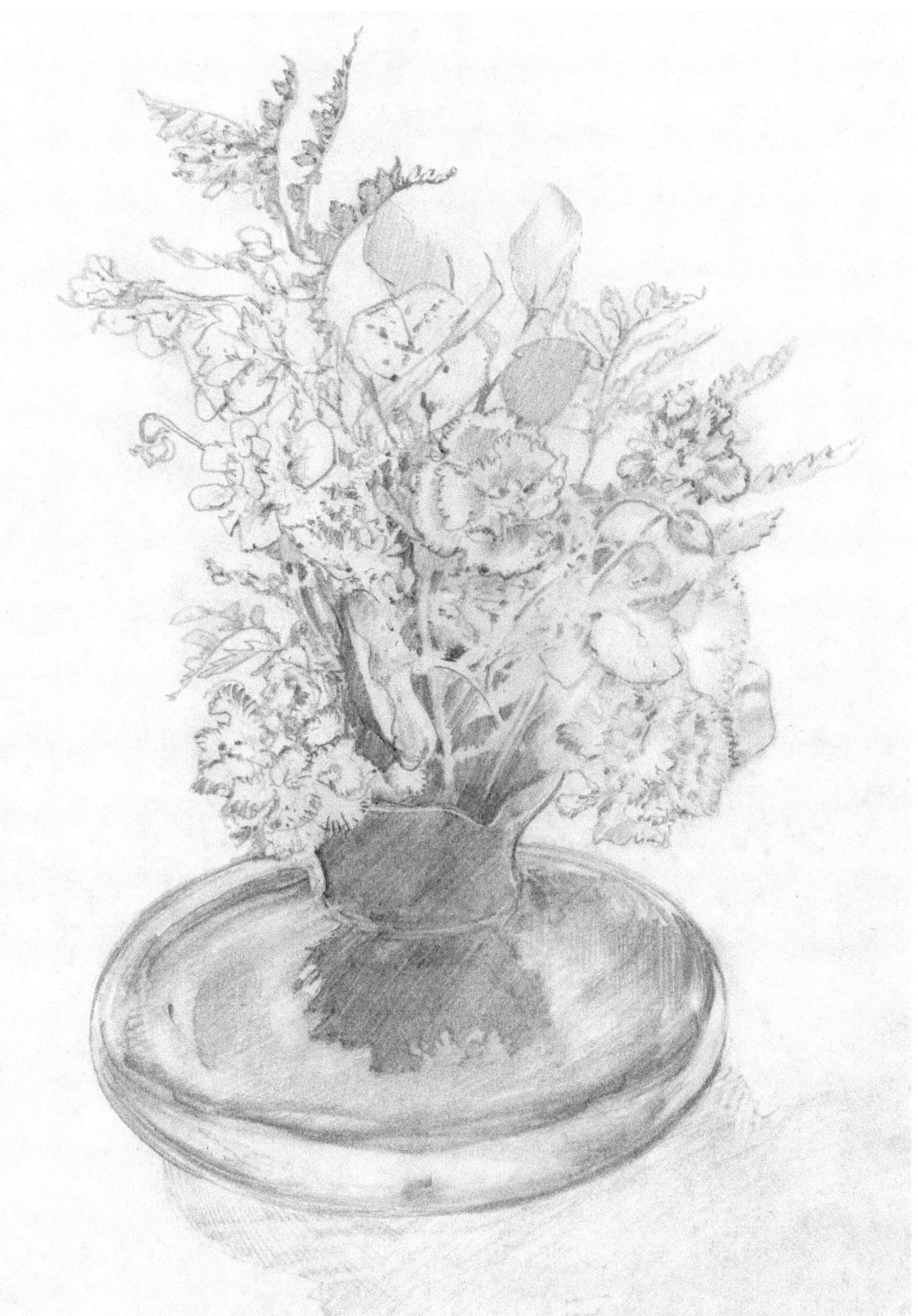

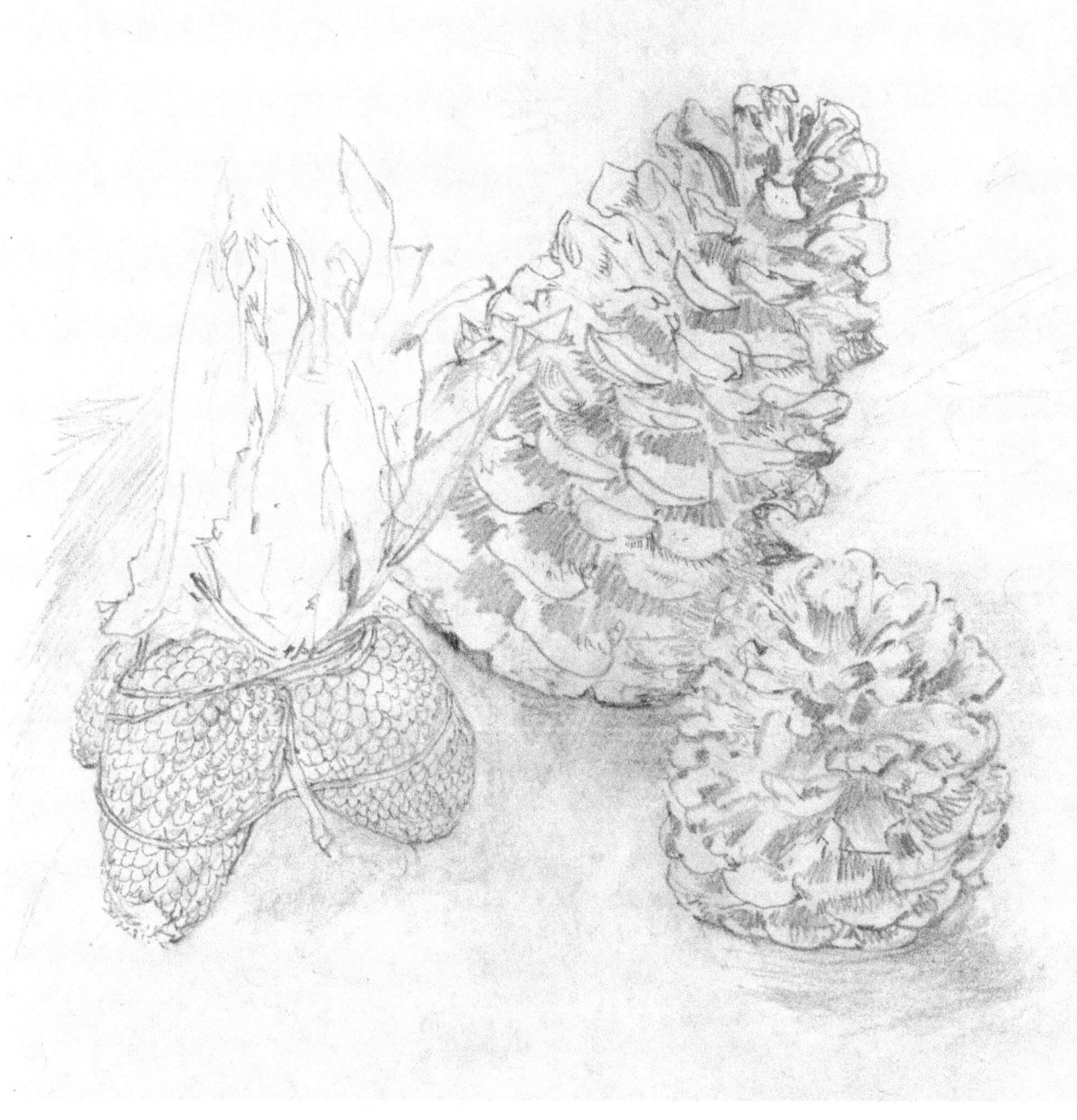

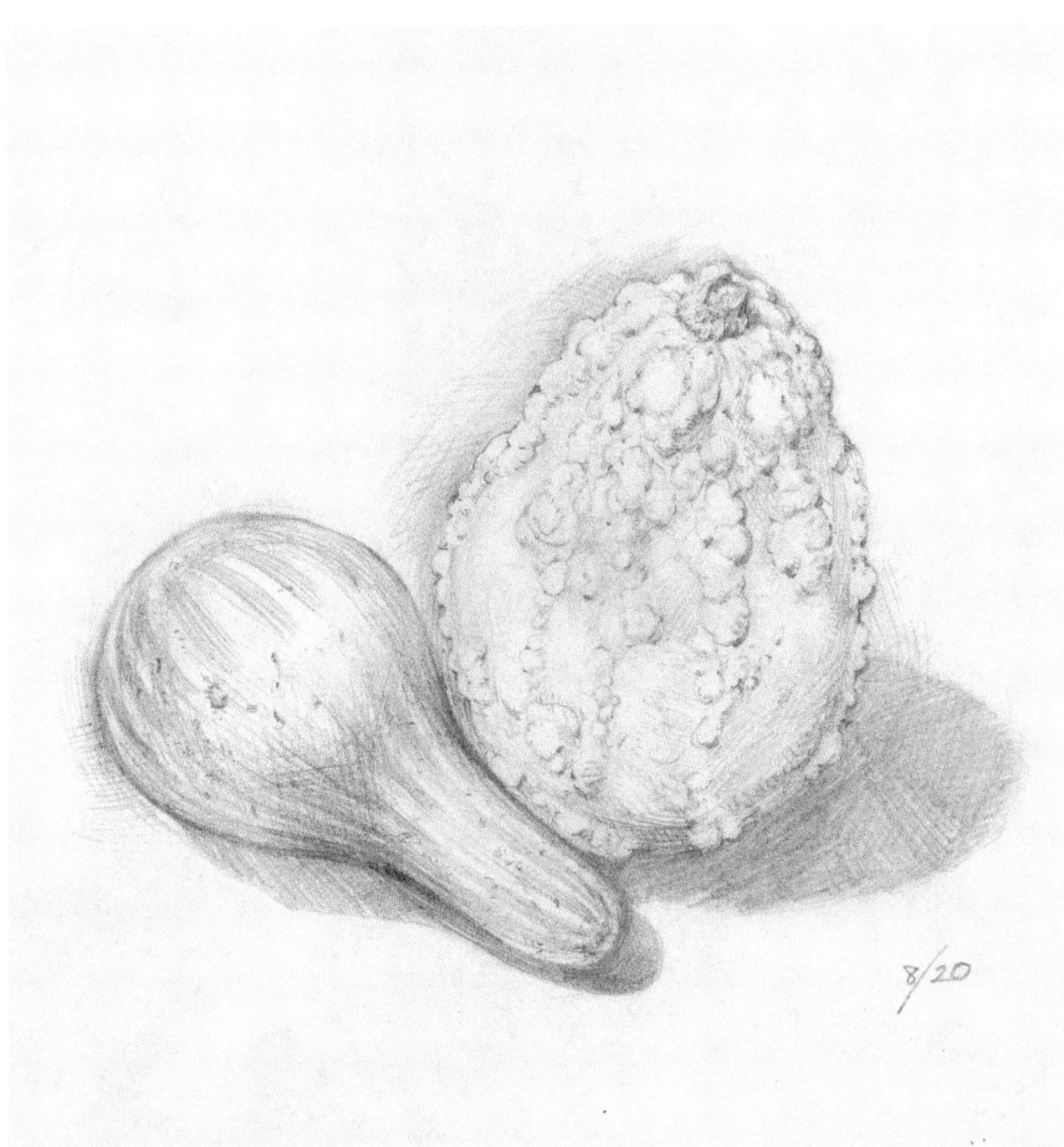

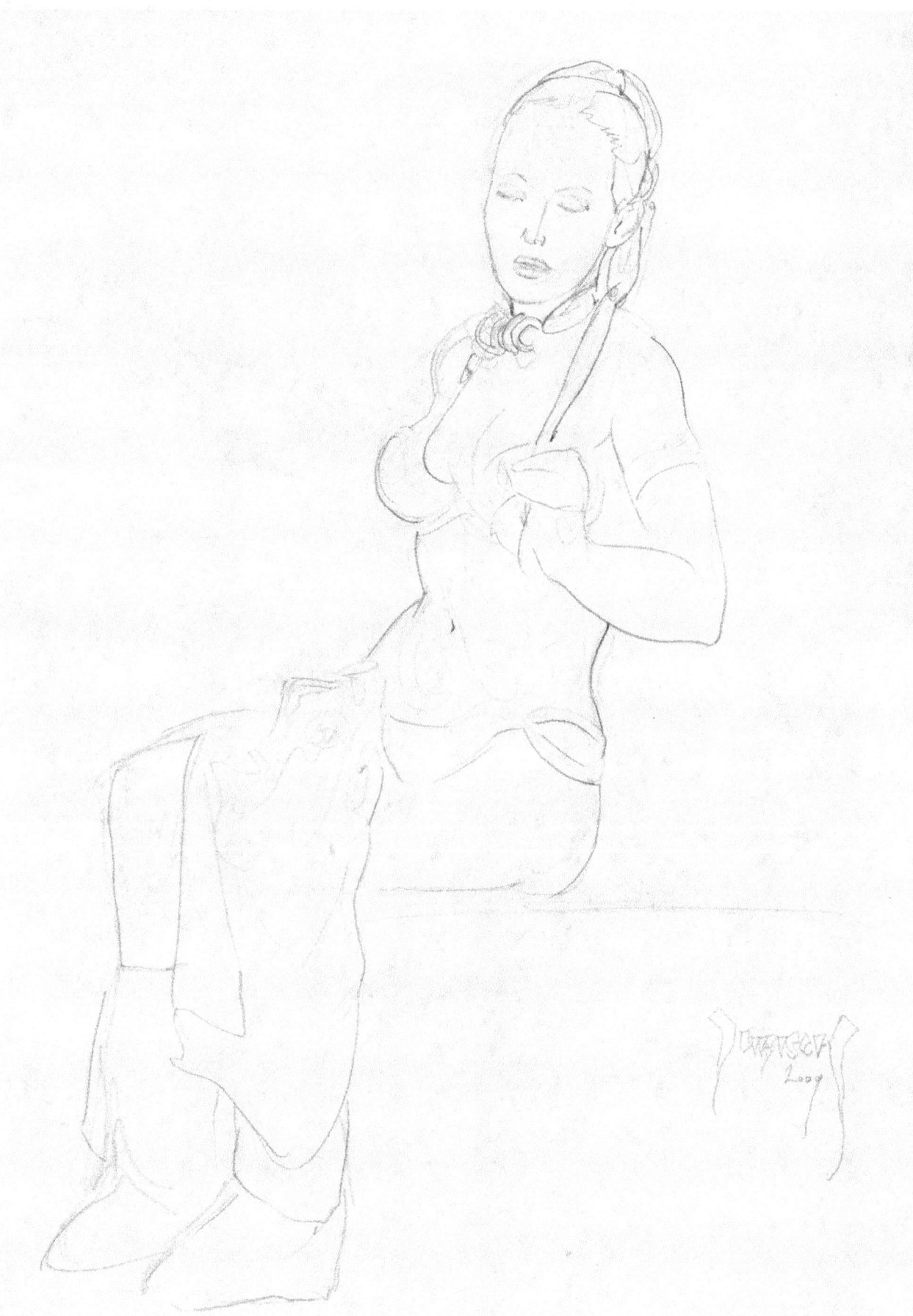

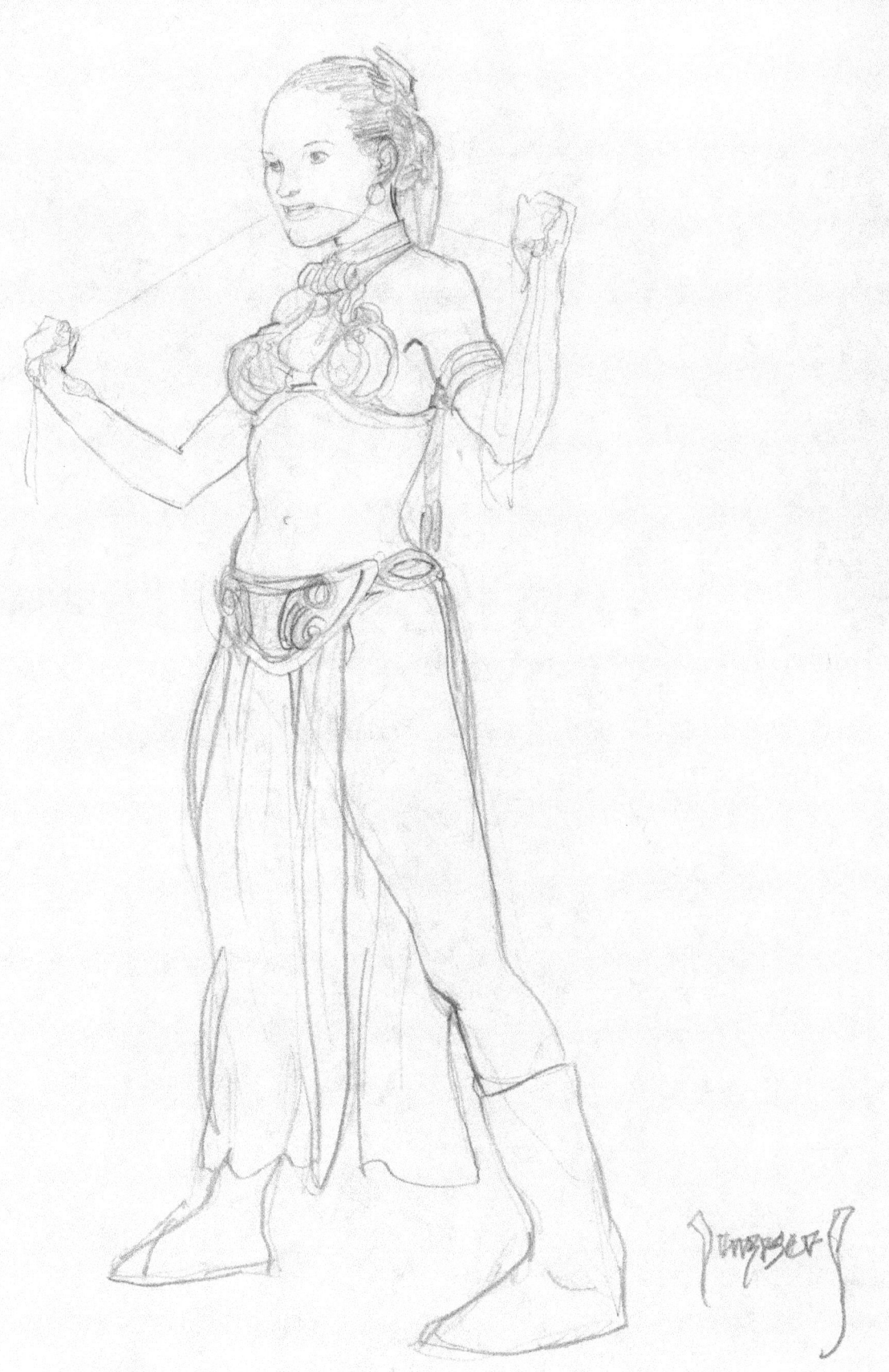

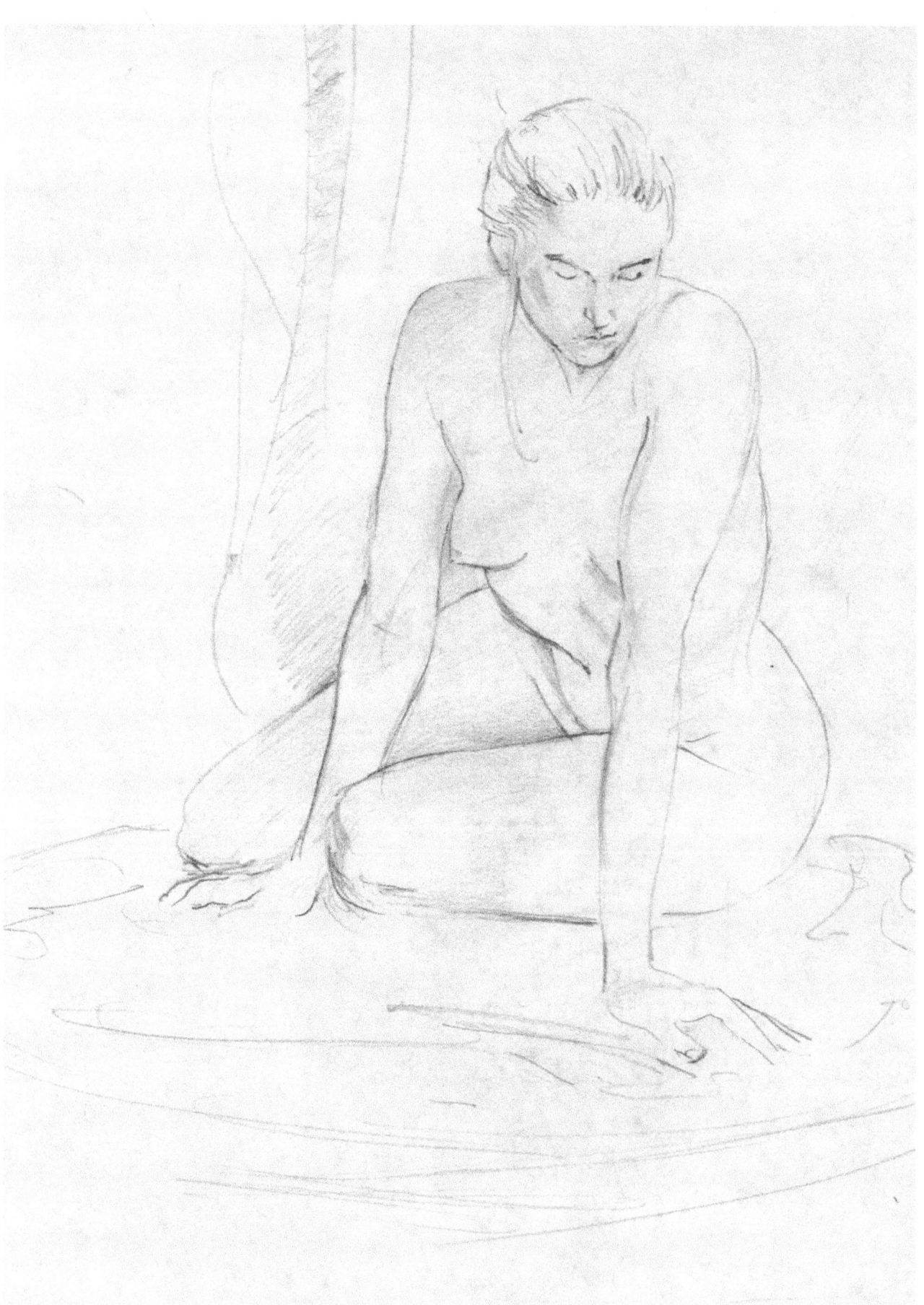

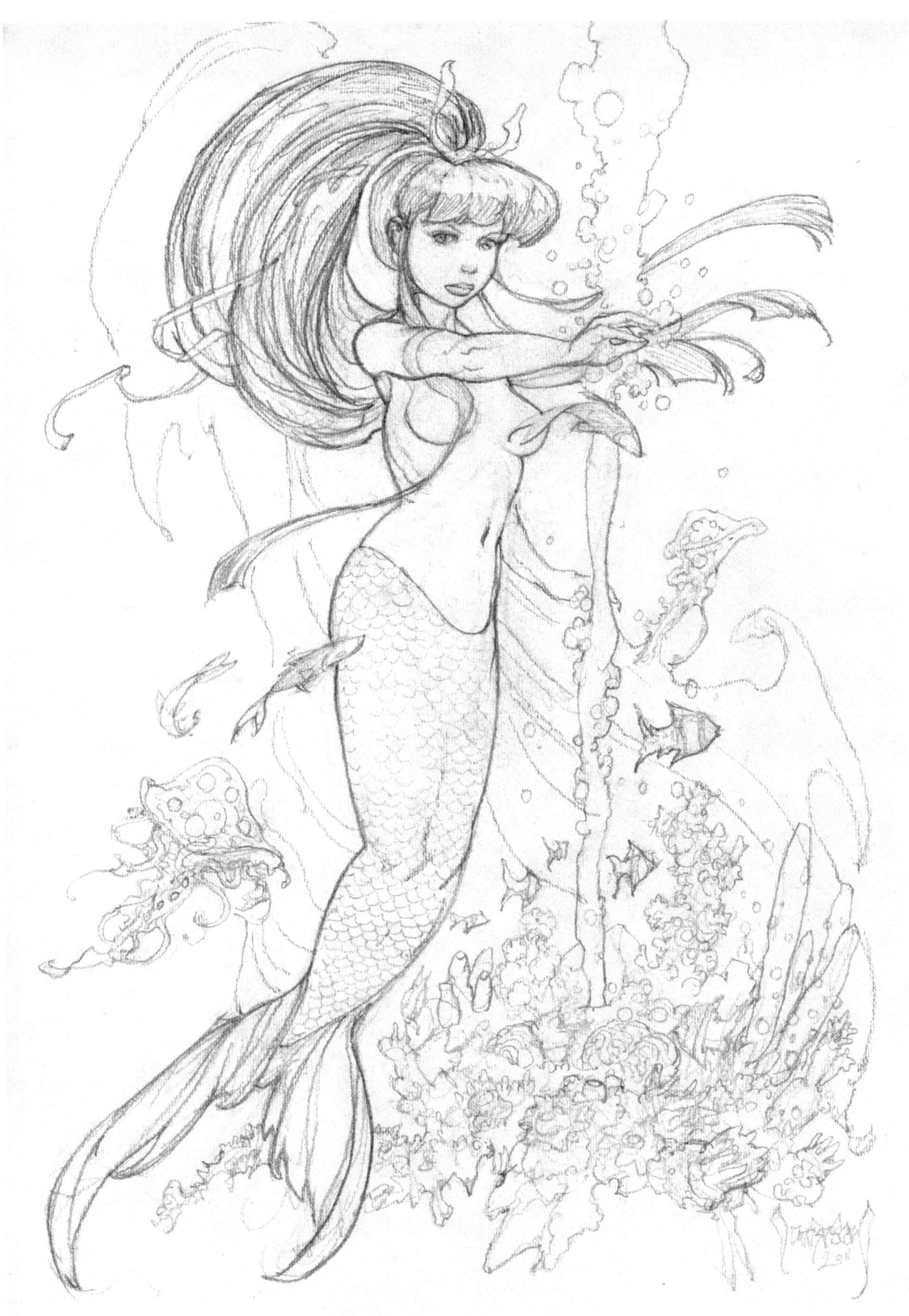

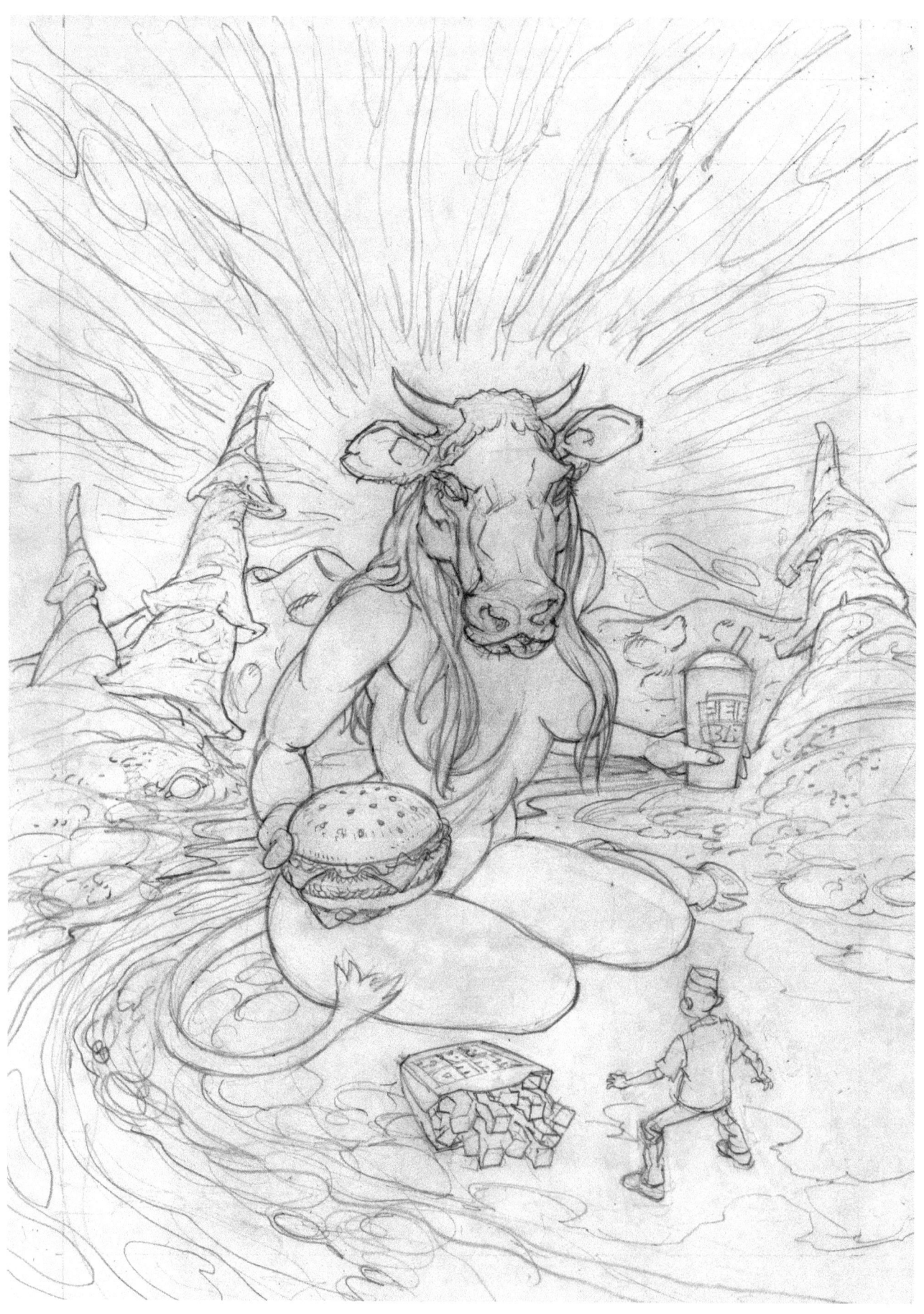

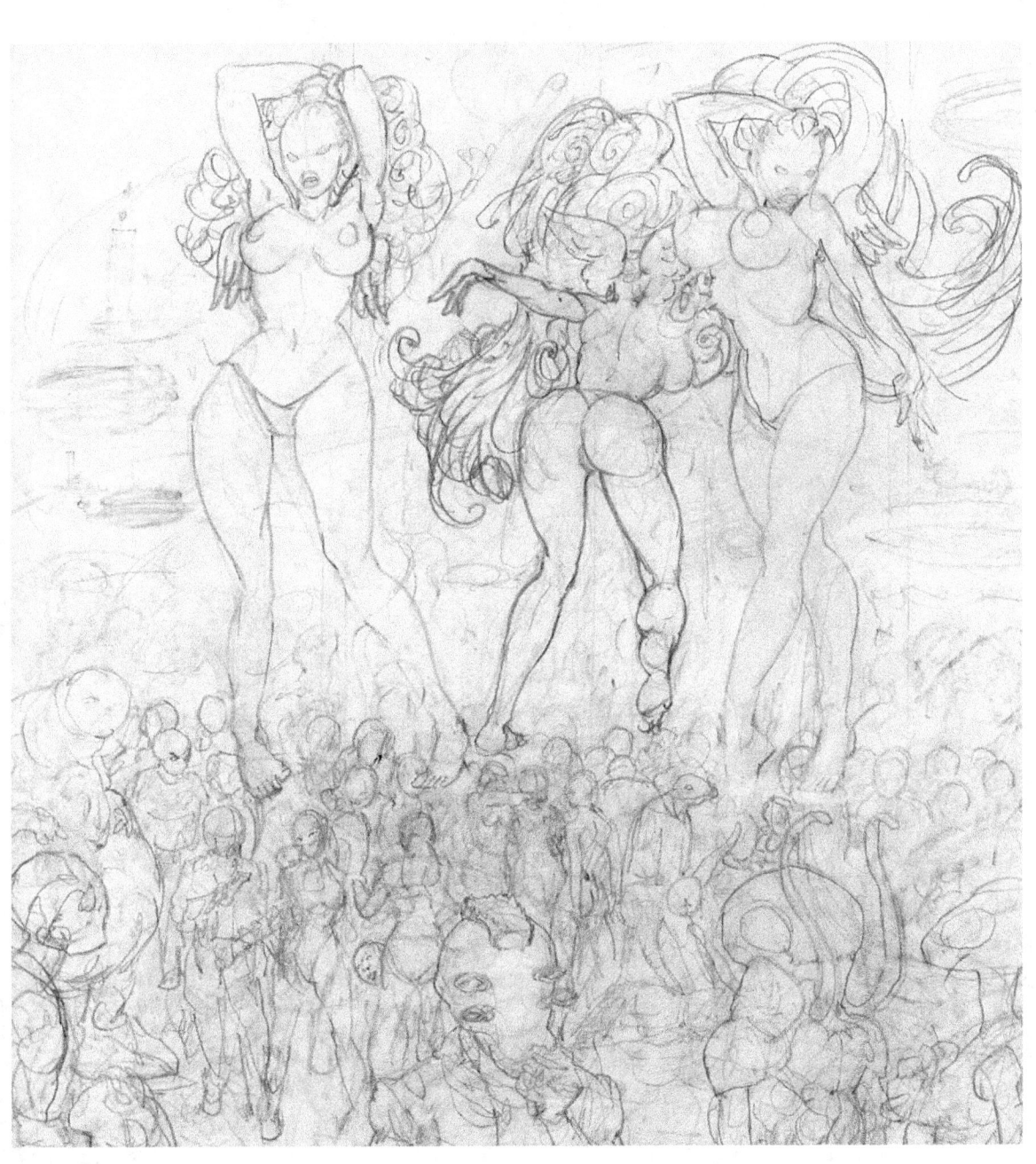

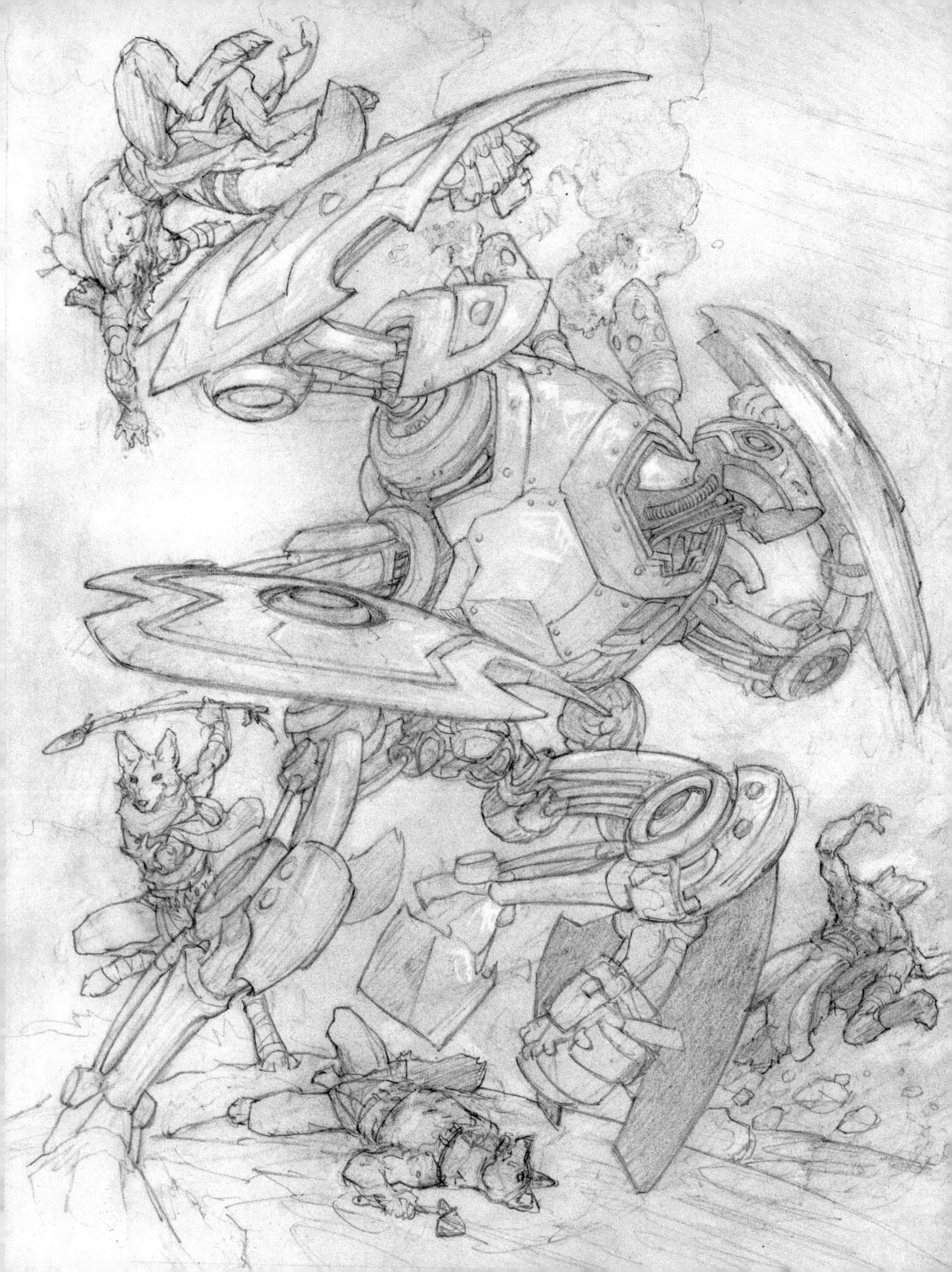

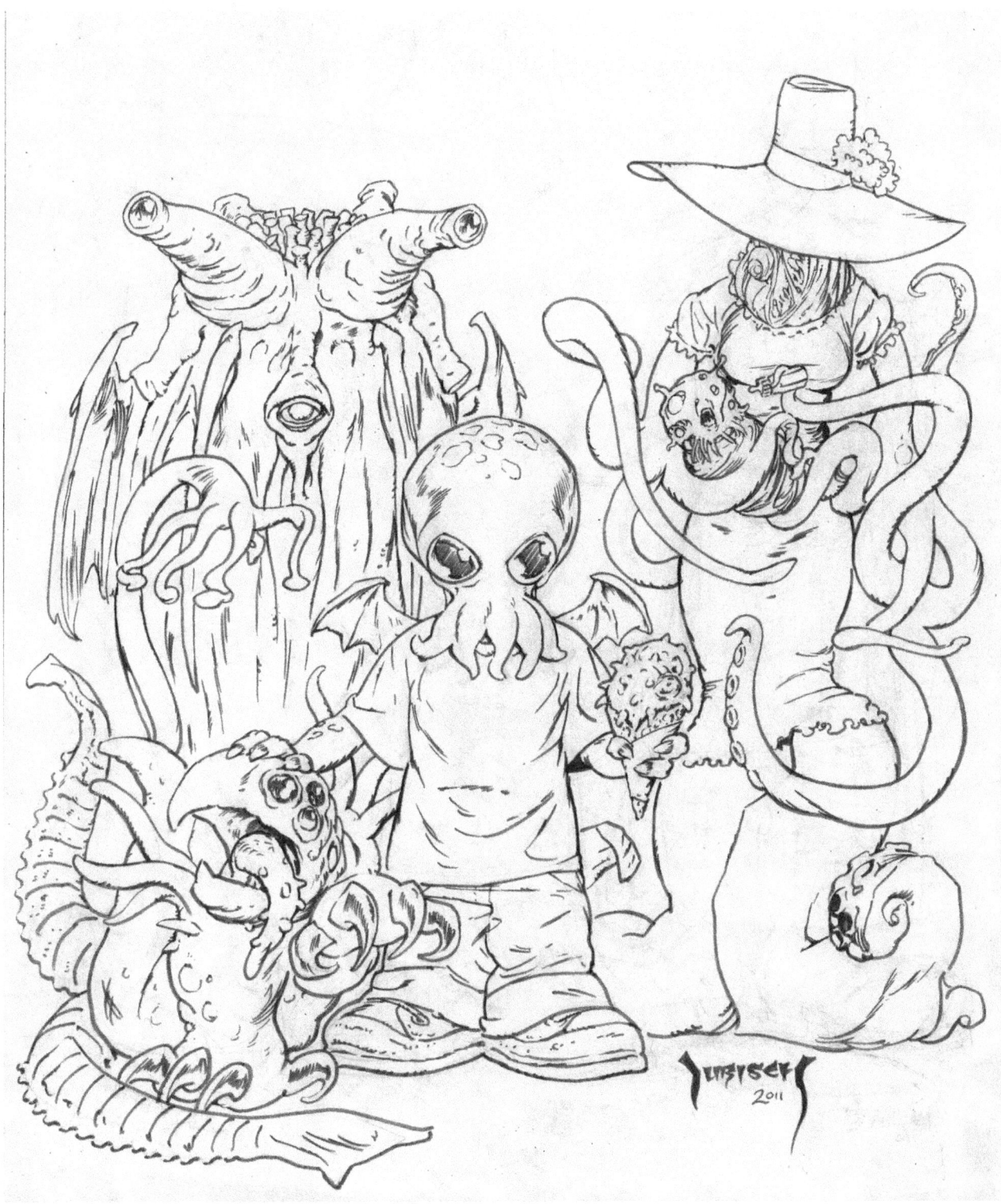

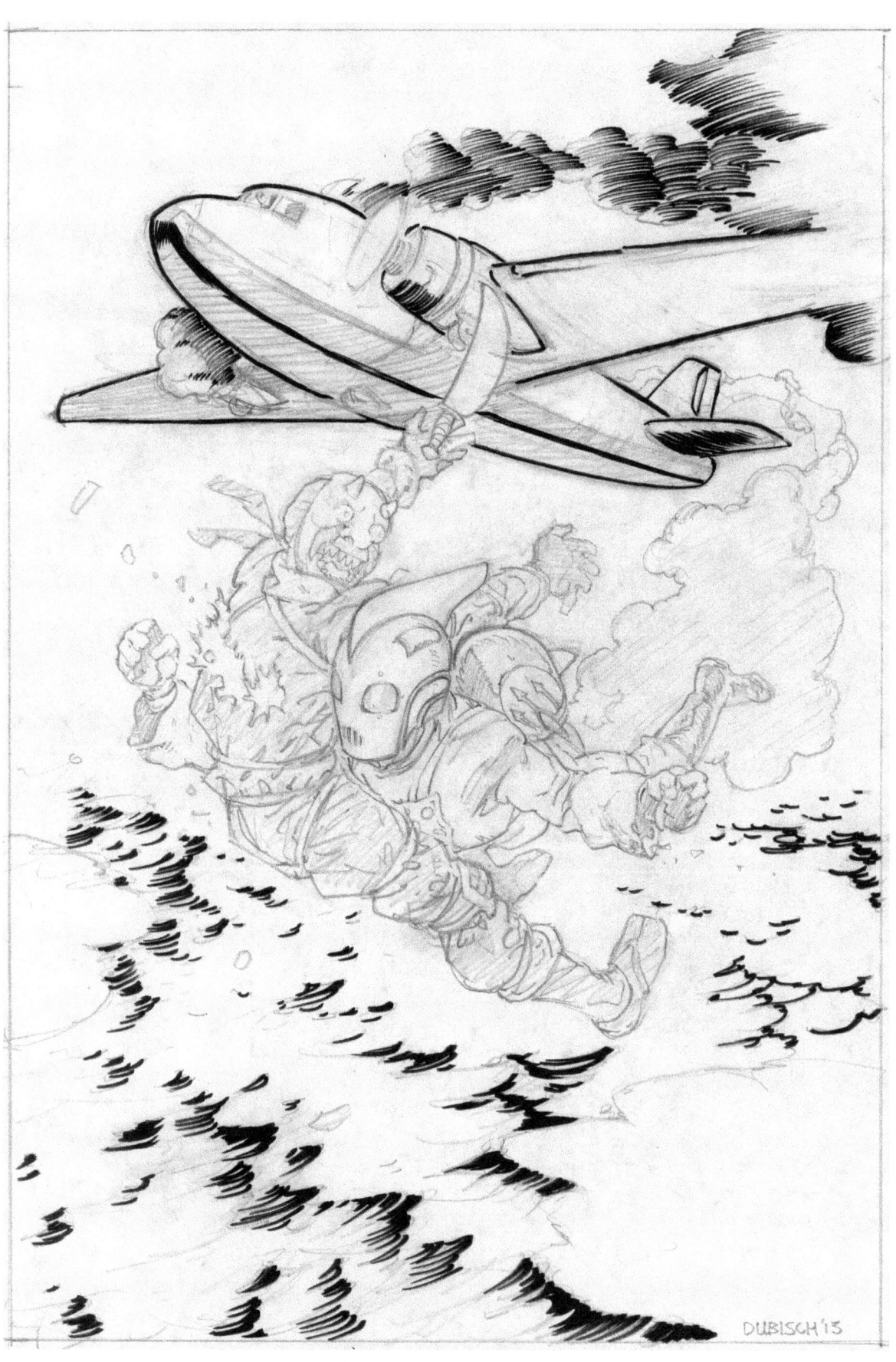

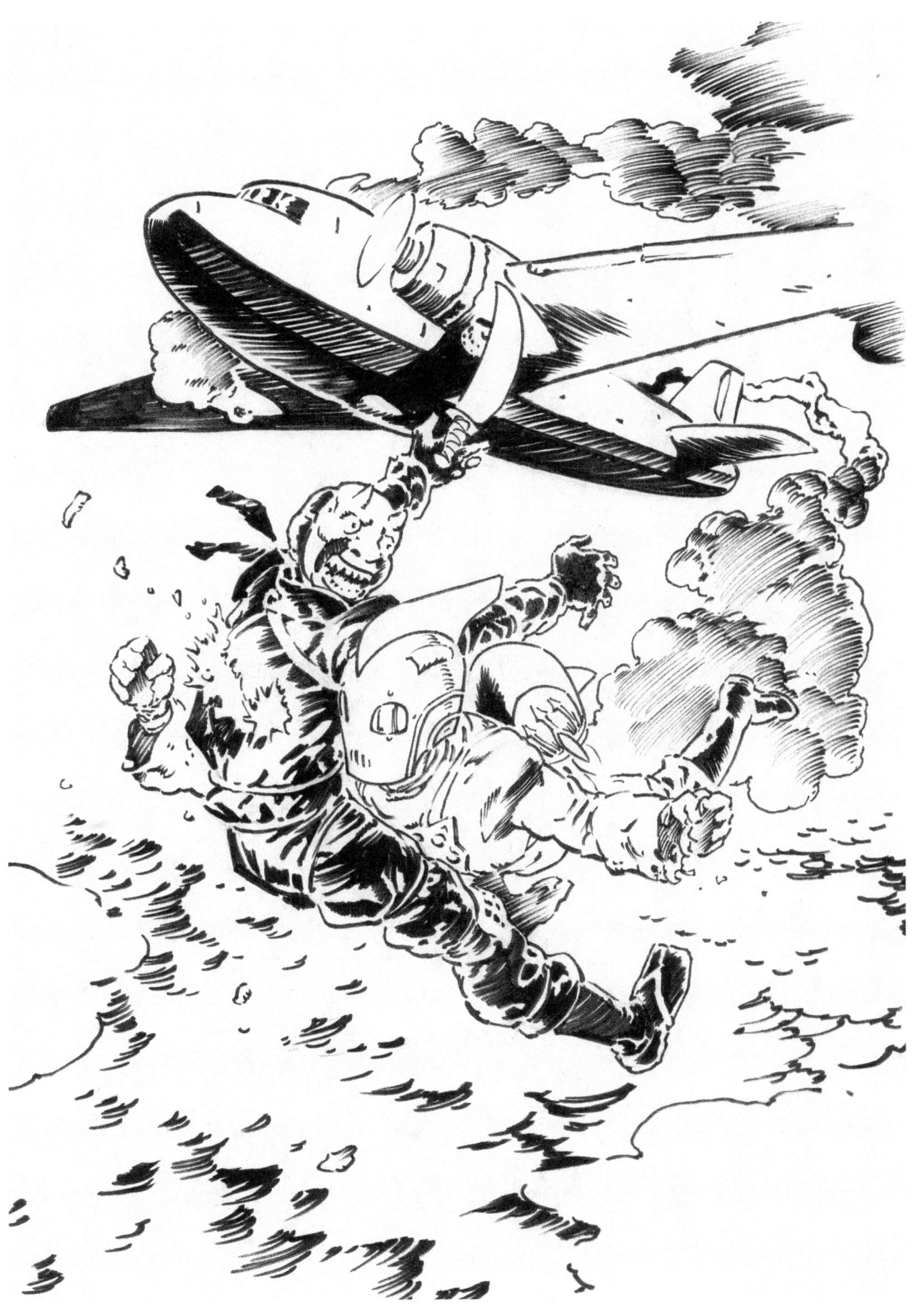

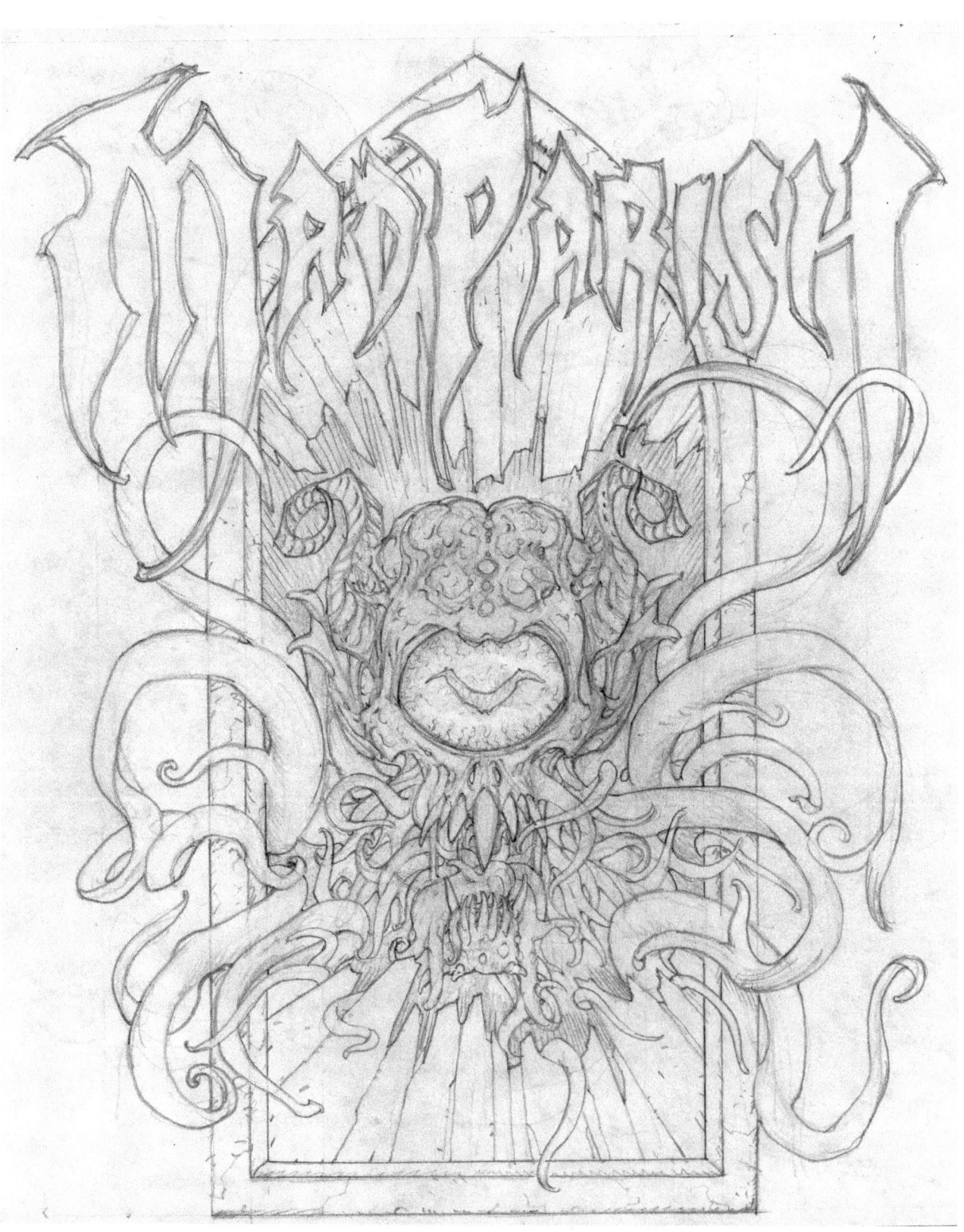

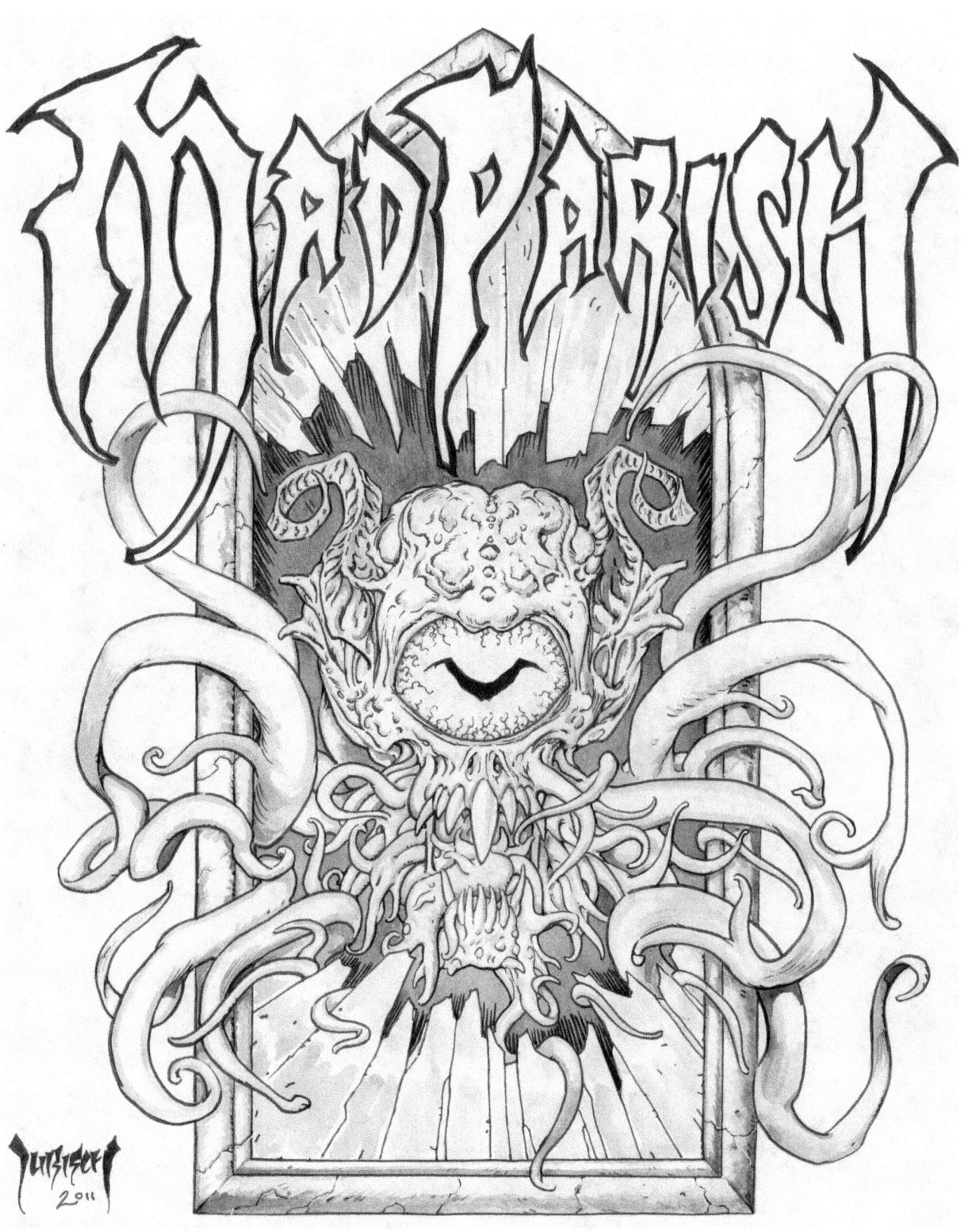

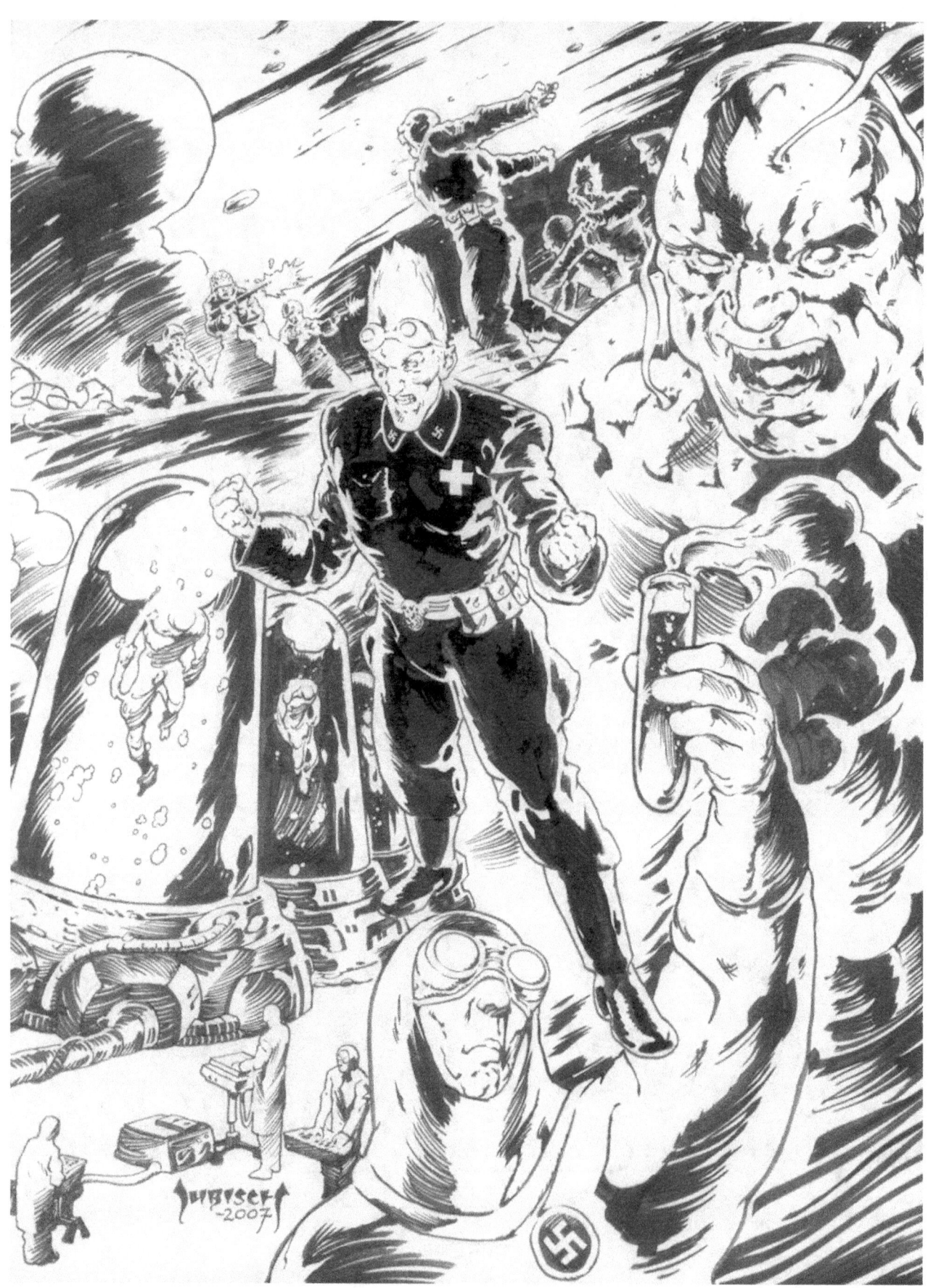

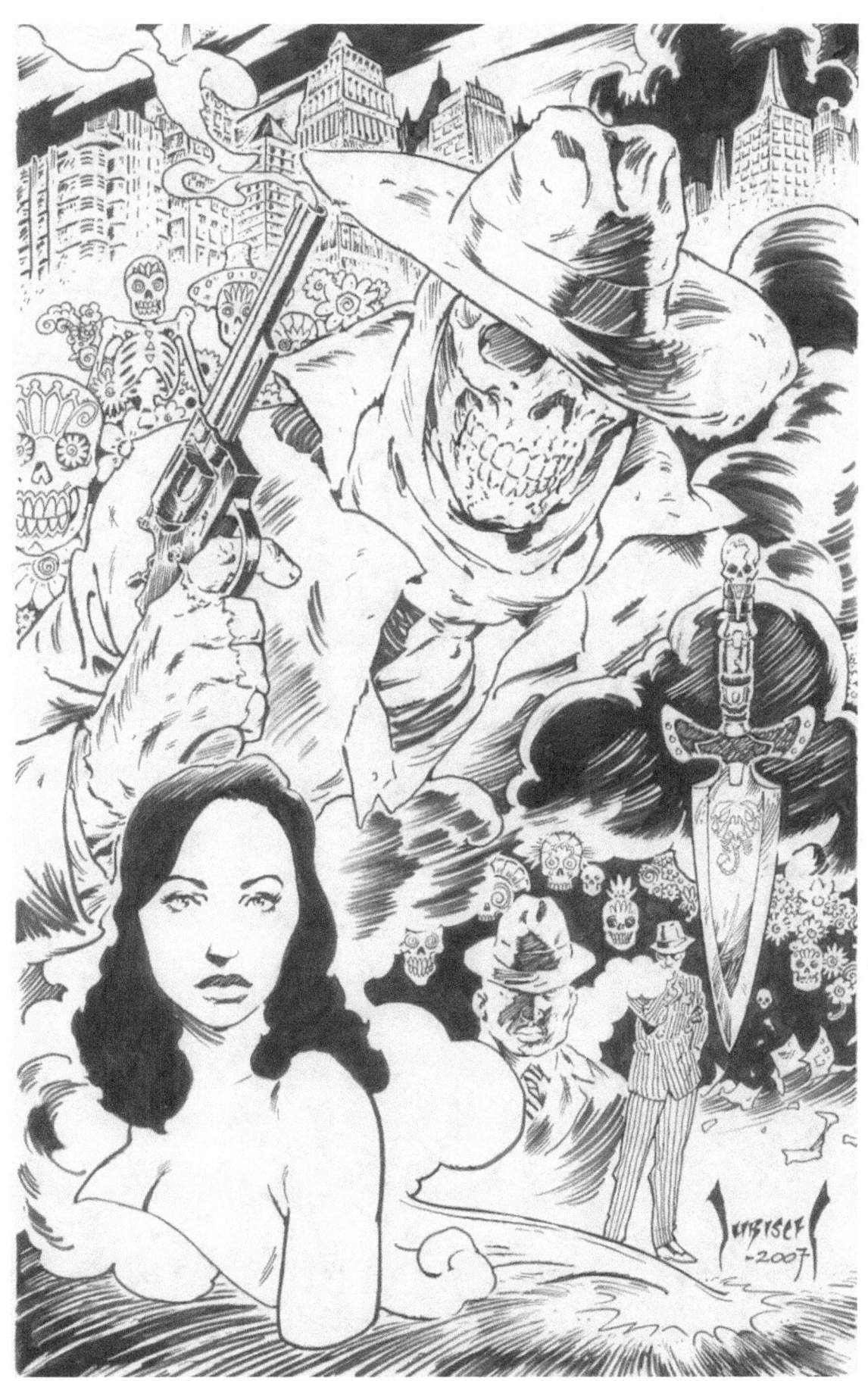

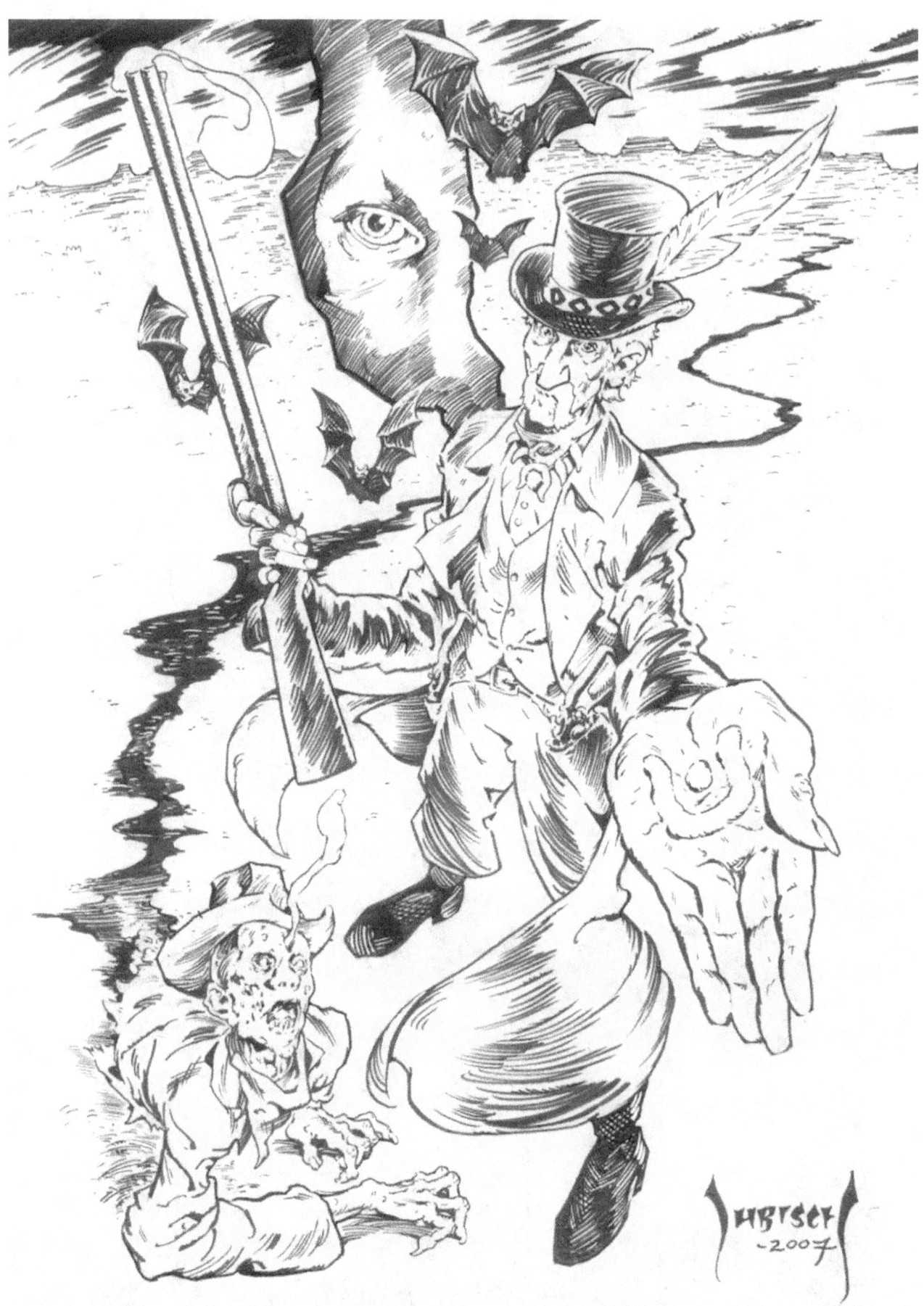

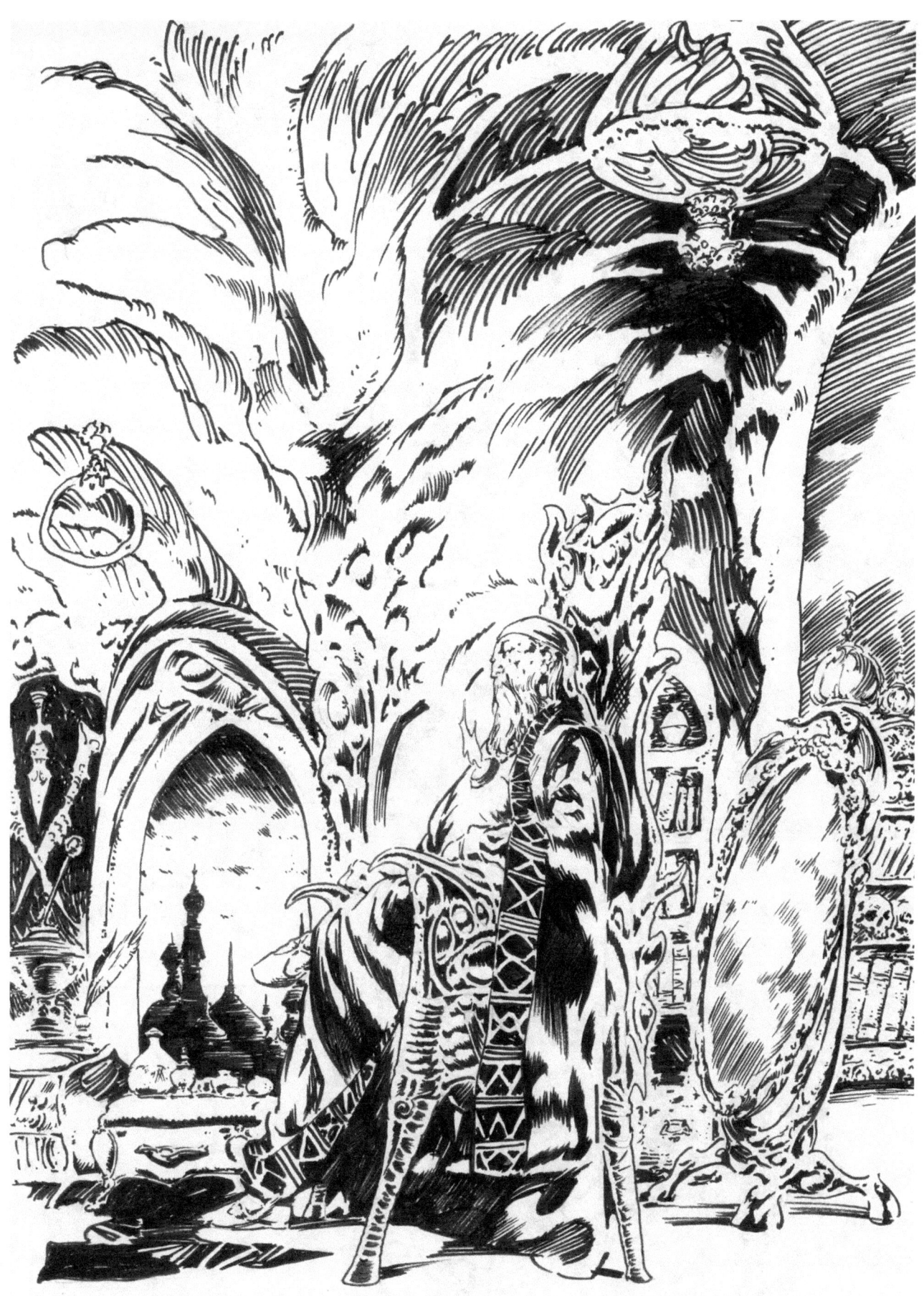

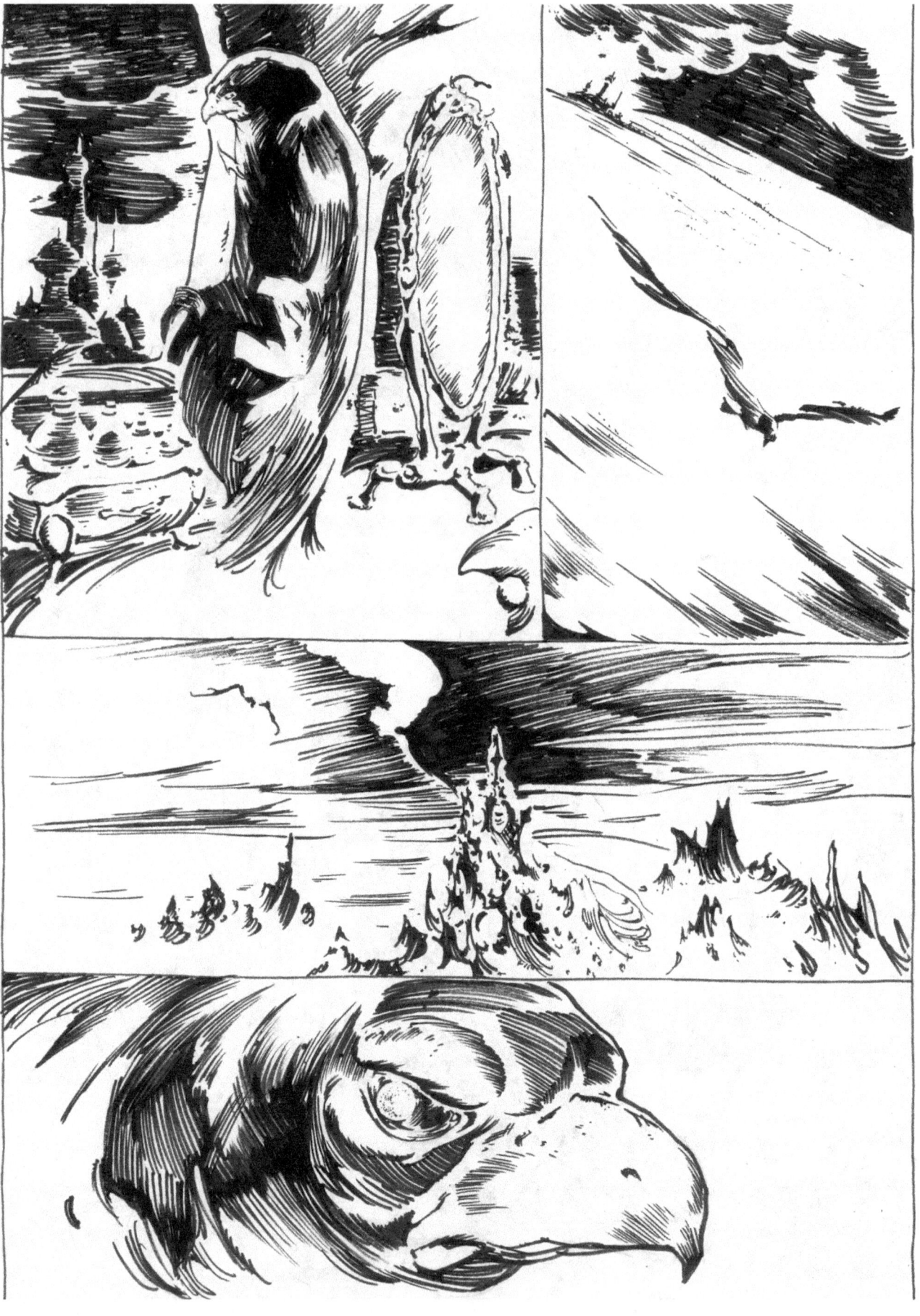

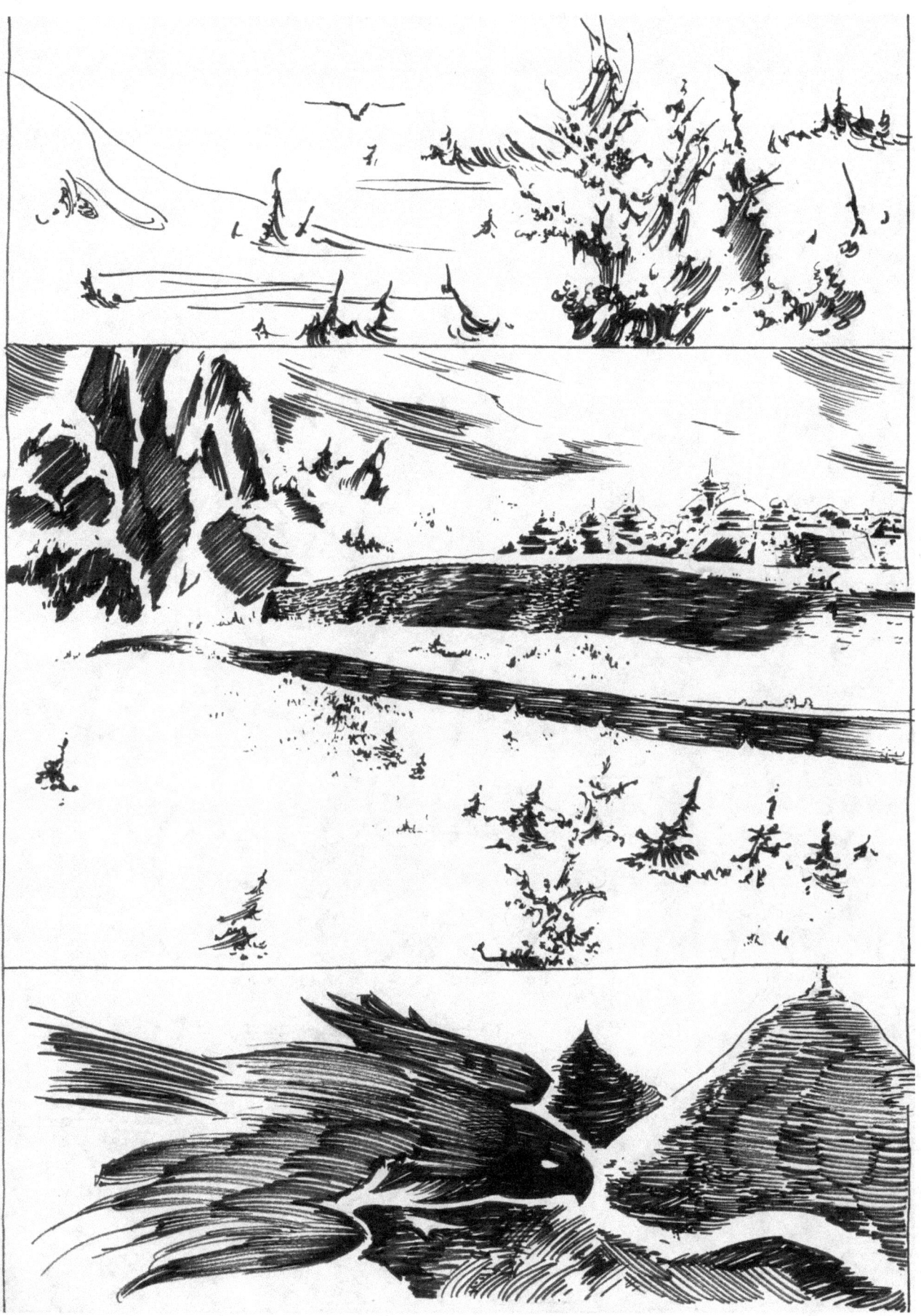

The Mike Dubisch Sketchbook Series
Collect Them All!

www.ingramcontent.com/pod-product-compliance
Lightning Source LLC
Chambersburg PA
CBHW080827170526
45158CB00009B/2537